The History of Cinema: A Very Short Introduction

VERY SHORT INTRODUCTIONS are for anyone wanting a stimulating and accessible way into a new subject. They are written by experts, and have been translated into more than 45 different languages.

The series began in 1995, and now covers a wide variety of topics in every discipline. The VSI library now contains over 500 volumes—a Very Short Introduction to everything from Psychology and Philosophy of Science to American History and Relativity—and continues to grow in every subject area.

Very Short Introductions available now:

ACCOUNTING Christopher Nobes
ADOLESCENCE Peter K. Smith
ADVERTISING Winston Fletcher
AFRICAN AMERICAN RELIGION
 Eddie S. Glaude Jr
AFRICAN HISTORY John Parker
 and Richard Rathbone
AFRICAN RELIGIONS Jacob K. Olupona
AGEING Nancy A. Pachana
AGNOSTICISM Robin Le Poidevin
AGRICULTURE Paul Brassley
 and Richard Soffe
ALEXANDER THE GREAT
 Hugh Bowden
ALGEBRA Peter M. Higgins
AMERICAN HISTORY Paul S. Boyer
AMERICAN IMMIGRATION
 David A. Gerber
AMERICAN LEGAL HISTORY
 G. Edward White
AMERICAN POLITICAL HISTORY
 Donald Critchlow
AMERICAN POLITICAL PARTIES
 AND ELECTIONS L. Sandy Maisel
AMERICAN POLITICS Richard M. Valelly
THE AMERICAN PRESIDENCY
 Charles O. Jones
THE AMERICAN REVOLUTION
 Robert J. Allison
AMERICAN SLAVERY
 Heather Andrea Williams
THE AMERICAN WEST Stephen Aron
AMERICAN WOMEN'S HISTORY
 Susan Ware
ANAESTHESIA Aidan O'Donnell

ANALYTIC PHILOSOPHY
 Michael Beaney
ANARCHISM Colin Ward
ANCIENT ASSYRIA Karen Radner
ANCIENT EGYPT Ian Shaw
ANCIENT EGYPTIAN ART
 AND ARCHITECTURE
 Christina Riggs
ANCIENT GREECE Paul Cartledge
THE ANCIENT NEAR EAST
 Amanda H. Podany
ANCIENT PHILOSOPHY Julia Annas
ANCIENT WARFARE Harry Sidebottom
ANGELS David Albert Jones
ANGLICANISM Mark Chapman
THE ANGLO-SAXON AGE John Blair
ANIMAL BEHAVIOUR
 Tristram D. Wyatt
THE ANIMAL KINGDOM
 Peter Holland
ANIMAL RIGHTS David DeGrazia
THE ANTARCTIC Klaus Dodds
ANTISEMITISM Steven Beller
ANXIETY Daniel Freeman and
 Jason Freeman
THE APOCRYPHAL GOSPELS
 Paul Foster
ARCHAEOLOGY Paul Bahn
ARCHITECTURE Andrew Ballantyne
ARISTOCRACY William Doyle
ARISTOTLE Jonathan Barnes
ART HISTORY Dana Arnold
ART THEORY Cynthia Freeland
ASIAN AMERICAN HISTORY
 Madeline Y. Hsu

Available soon:

For more information visit our website

www.oup.com/vsi/

Geoffrey Nowell-Smith

THE HISTORY
OF CINEMA

A Very Short Introduction

OXFORD
UNIVERSITY PRESS

Great Clarendon Street, Oxford, OX2 6DP,
United Kingdom

Oxford University Press is a department of the University of Oxford.
It furthers the University's objective of excellence in research, scholarship,
and education by publishing worldwide. Oxford is a registered trade mark of
Oxford University Press in the UK and in certain other countries

© Geoffrey Nowell-Smith 2017

The moral rights of the author have been asserted

First edition published in 2017

Impression: 1

Published in the United States of America by Oxford University Press
198 Madison Avenue, New York, NY 10016, United States of America

British Library Cataloguing in Publication Data

Data available

Library of Congress Control Number: 2017943621

ISBN 978-0-19-870177-4

Printed in Great Britain by
Ashford Colour Press Ltd, Gosport, Hampshire

Links to third party websites are provided by Oxford in good faith and
for information only. Oxford disclaims any responsibility for the materials
contained in any third party website referenced in this work.

Contents

Acknowledgements

My thanks are due to Stephen Crofts, Andrew Klevan, Richard Maltby, and Tony Miller BSC for their constructive comments on the manuscript of this book in the course of its preparation; to my editors at Oxford University Press, Latha Menon and Jenny Nugee; to my family, for their patience throughout; to Dan Harding for his scrupulous copy-editing and to Deborah Protheroe for picture research; and to the many contributors to my *Oxford History of World Cinema* (Oxford University Press, 1996), whose work I have remorselessly pillaged, often uncredited, in putting together this slim volume.

Copyright acknowledgements are made to the rightsholders in the illustrations list to this book.

Acknowledgements

List of illustrations

Chapter 1
Introduction

What is cinema? What is history? What, putting the two together, is, or would be, a history of cinema?

Start with 'What is cinema?' This sounds like a simple question, but there is no simple answer to it. Cinema is films, the machinery that makes them, and the places where people go to see them. It is a technology, an industry, an art form, a way of viewing the world—or of creating worlds to be viewed. Its material existence takes the form of studio sets, editing suites, reels of celluloid film which come alive when projected to an audience gathered together in front of a screen; but it also exists immaterially in the form of remembered images which together make up a significant part of the cultures of people across the globe.

Not only is it a combination of all these things, but the combination has taken different forms at different points in the hundred or more years since its inchoate beginnings. For the first fifteen years of its existence, from the mid-1890s to 1910 or thereabouts, one would have been hard put to say exactly what it was or was likely to become. It had barely passed the stage of being a technological novelty and a fairly primitive one at that, with its hand-cranked cameras and flickering projection. Outside the cities it had no stable venues. In some parts of the world it was to all intents and purposes unknown. Films were mostly short,

fifteen minutes at most, and very roughly put together. It was a thriving business, with films from France, Denmark, Italy, and the United States competing in Western markets, but it had yet to consolidate itself as an industry. Artistically it remained parasitic on existing forms of entertainment and spectacle. Its potential uniqueness as an art form that was both temporal and spatial, narrative and pictorial, and based in each case on the objectivity of the photographic image, remained to be exploited. Almost all the things it was later to become were still in an unknown future.

Contrast this with the situation that prevailed from, roughly speaking, 1920 to 1980. Throughout this period, there was little doubt what cinema was and what its boundaries were. It was a consolidated industry, operating worldwide. It had refined its technology, incorporating synchronized sound around 1930 and steadily transiting from black and white to colour for most major productions. It had its own forms of narration and presentation of real or imagined worlds, no longer dependent on literary or stage models. If it continued to draw on novels and plays for its material, it did so according to its own rules and in the case of genres such as the western or the musical (though not perhaps in the case of adaptations of novels by Henry James or plays by Samuel Beckett) it was more than a match for its literary or theatrical originals. It had acquired new ways of presenting and probing phenomenal reality under the guise of what came to be called documentary. It even had a small dedicated artistic avant-garde, operating outside the industrial mainstream.

Most of all, however, the cinema was a place to go. Almost universally, films were shown in public places known in Britain as cinemas and in North America as movie theatres, and to an audience. They were also made and projected on celluloid film. The only exception to this was when they reappeared on television, which they did in increasing numbers from the 1950s onwards, notably in the United States where there were many channels to fill. But watching films on television was a

2

recognizably second-rate and second-hand form of viewing. The screen was small, the image degraded, and many people's sets even in the 1970s were black and white. Watching movies on television could never be mistaken for cinema, which was clearly something else. Where television excelled was in the area of the factual film, and the main effect of the new medium was to push newsreels and to some extent documentaries off the commercial cinema screen, which became almost exclusively the home of fiction films. Apart from that, the boundaries of what was recognized as cinema remained remarkably stable for over half a century.

Since the 1980s, however, enormous changes have taken place in the world of audiovisual media, and the clear boundaries that used to exist throughout most of the 20th century have once again become blurred. In many ways, indeed, we are back in the state of affairs that prevailed a century ago when the cinema—or what was to become cinema—was struggling to differentiate itself from surrounding forms of spectacle. It is not that the cinema itself has changed that much, but that it has been encroached upon on every side by other sorts of media whose nature can be summed up in a single word: digital. Digital has affected cinema directly in that digital cameras and projectors, and above all digital manipulation of the film image, have given cinema a new technological base. But it is changes in the environment in which it operates that have been of more fundamental importance. As late as the 1970s cinema had no living history. If you missed a film when it came out you would have great difficulty in seeing it again except as a member of a dedicated film society or if it cropped up, in inferior form, on television.

Now, however, great swathes of past cinema are available to be owned or rented on DVD or Blu-ray or can be streamed or downloaded off the Internet. Cable and satellite television now offer more movie channels than one might care to count. Not only are more films available but the image and sound quality can be

almost as good as watching a fresh print of a new film in a regular movie theatre. All that is missing from these alternative forms of viewing is the cinema audience. Not only has cinema modestly downscaled itself to become home entertainment, but television has expanded into areas that were once the province of cinema. The traditional 25- or 50-minute episodes of a crime series have increasingly mutated into feature-length narratives, almost indistinguishable from cinema films and subsequently available as a boxed set.

The question 'What is cinema?', then, cannot be answered in the abstract as if cinema were a single unchanging thing for which all one needed to do was provide a definition valid for all times and places. Nor can it any longer be imagined teleologically, as if from uncertain beginnings it later became fully the thing it was destined to be. On the contrary, it was and is something in constant flux. For the purposes of this book I shall treat cinema as a complex of things: a technology or set of technologies; an industry or industries; an art form or forms; a way or ways of rendering the world as images and sounds; and as a component of the imaginary world each of us keeps inside our head. In all these manifestations the entity cinema has very fuzzy boundaries, overlapping with other technologies, industries, art forms, modes of representation, and presences in popular culture. Some of these boundaries I shall stray across from time to time but I shall also make exclusions, for example by treating cinema as a public medium, always designed for an audience even if that audience sometimes consists of one person at a time. Uses of the film medium purely for the purposes of scientific research, for surveillance, or simply for creating a record or as home movies will not be treated under the rubric cinema.

How is one to tell the history of such a wide-ranging phenomenon as cinema? Again, something in the order of a provisional definition is in order, this time of history itself. History, historians regularly point out, is not the same as the past. The past has been

and gone. It won't come back, and what it was is largely irrecoverable. History is the account that can be given of things that once were and have left enough traces for an account to be given of them. It exists in the form of archaeological and documentary records (including film records and audio-recorded memories) and in the form of the construction that can be made of what these records can be held to imply about the past state of things. This construction can take many forms, and protocols exist to ensure that the construction historians make is not overly fanciful or tendentious. But it remains a construction, or indeed many constructions, since there are many different things of which constructions have to be made, and many different people with reasons to make constructions of the part of history in which they most have a stake.

History, then, has come more and more to be seen as an unstable amalgam of different histories—economic history, social history, women's history, cultural history, history of ideas or of sexualities, and so on—and less and less as a single story with political events always in the foreground. With this has come an increasing focus on slowly changing structural factors at the expense of easily narrated events. This shift has been provocatively summed up under the slogan: 'menarche is more important than monarchy'—that is to say, the age at which girls reach puberty and so become capable of reproduction has more long-term effects on historical development than all the doings of kings and queens and parliaments and battles on which many of us were brought up at school.

The changes in the idea of what history is and how it should be told have been slow to make an impact on the closed world of film history. Up until the 1970s and indeed later, the history of cinema has mainly taken the form of a history of films (preferably famous ones) with a sidelong glance at their makers (producers, writers, directors, actors) and the conditions under which they got to be made. The evidence has tended to be that which was most readily

available, which meant, in many cases, the memory of the historian of the films that he or she had been lucky enough to see a long time ago but had not been able to see again.

One cannot blame early film historians for proceeding in the way they did. What they wrote about was what their readers were interested in, just as the history of kings and queens continues to be interesting to readers of general history. More importantly, what else was there for them to write about? Much of film history had already been lost, particularly that of the silent period when films that had had their run were regularly recycled to save the precious silver salts that formed the light-sensitive emulsion on which the image was recorded. Other films had perished of their own accord—in fires or because of poor storage conditions. And few people cared. Films were thought of as ephemeral products and it was not until the 1930s that any film archives existed in which to preserve films thought to be worth preserving. Written documentation was also thin on the ground. The records of film studios were jealously guarded and were rarely accessible to scholars, and it was many years before it was realized that court records, for example, contained crucial information that had been forced into the public domain by the needs of the trial process.

Belatedly, then, in the past thirty or forty years new questions have begun to be asked about the history of cinema, and new sources of information uncovered with the aid of which to answer them. Interest has been focused on run-of-the-mill production as well as on films judged to be of singular importance, and on the history of their reception by audiences as well as their production and distribution. Different and often contrasting methodologies have been applied, sometimes to the same subject, so that the history of reception, for example, has been looked at both by methods similar to those of market research (as already practised by the film industry) and in a more speculative vein to seek out the complex satisfactions that cinema has offered at different times in history. In terms of causation, a belief in the primacy of

technology gave way in the 1970s to a Marxist concentration on economics and then to an eclectic mix of methodologies which have reinstated changes in collective subjectivities as a motor force in how cinema makes its presence felt in history.

The consequence of the work done in recent years has been to align the history of cinema more closely with what is regarded as history in other spheres and establish links with other lines of enquiry, sociological, economic, aesthetic, psychoanalytical, and beyond. In so doing it has reinforced the picture of cinema as a complex and multifaceted institution whose parts stand in constantly changing relationships with each other and with aspects of the world outside its immediate boundaries. What it has not done is succeed in imposing any single template for how cinema history is to be written. As in other branches of history, there will continue to be many different cinema histories. This little book cannot tell all of them, dot all the i's or cross all the t's, but hopefully it will give an idea of what it took for cinema to become the major art of the 20th century.

Chapter 2
Technology

Cinema is in the first instance a technology, or set of technologies, and the technologies it puts to work—optical, photochemical, mechanical, and more recently digital—form part of its basic definition. Cinema, or what was to become cinema, came into being as a result of the combination of the basic technologies of photography as developed in the 19th century (focusing lenses, light-sensitive emulsions) with a mechanical device to enable photographs of moving objects to be taken in quick succession and played back so as to create the illusion of the movement of those objects. There was nothing in the initial application of these technologies to suggest that their combination would produce a new art form, but that is what they did. When they did, the art form they produced was not at all what the pioneers of early cinema technology would have expected. Almost all examples of the art form that developed are what they are only because they apply some form of technology to the basic task of making objects seem to move. Natural objects can be replaced by painted designs, as in classical animation; photosensitive emulsions by digital capture of potential images; the jerking of celluloid film through a projector by the seamless succession of digitized images. Methods of viewing can change too. Some early films could only be viewed as a peepshow, though cinema proper only came into being when film could be projected. Nowadays most viewing of films (again, perhaps, not proper cinema) is not of projected

images at all but on liquid-crystal display screens as used for viewing television.

Whatever the specificity of the technologies employed and their exact combination, they remain technologies, and without them there would be no cinema, or, put another way, what you get would not be cinema. In this respect the cinema, following in the steps of photography, is fundamentally unlike any previous art form or indeed most subsequent ones. Other art forms may use technology, but the use of technology is not part of their definition. Music may use finely crafted violins or hi-tech synthesizers, but it can equally well be produced using hollowed out logs or just the human voice; poetry can be written down, with a pen or on a computer, it can be spoken aloud, or recorded to be reproduced on the radio; drama only requires actors performing for an audience; dance can be performed without even an audience and simply for the pleasure of the dancer; painting may seem to require paint, but drawing can be done by scratching without even a pencil. It is the nature of the object or performance produced and the effect it has that enables us to specify what it is; the material means by which it is produced are important and are often technological, particularly nowadays, but a song is a song and you can sing it to yourself in the bath even in the absence of the record on which you first heard it.

Cinema, however, evolved from a technology and remains technological even if parts of the original technology have changed, been replaced by newer ones, or even in some cases done without (you can, for example, make film images without a lens, though you would need a lens in order to project them). Furthermore, the history of cinema can be, and sometimes has been, told as a history of the evolving technologies with which films were produced and displayed. The key events in such a history are the transition from silent cinema to cinema with synchronized sound, which happened very rapidly around 1930; the shift from black and white to colour, which took place rather

more slowly from the mid-1930s onwards, becoming universal only in the mid-1960s; the enhanced spectacle offered by widescreen projection and stereo sound from the mid-1950s onwards and the countermove to lightweight cameras and tape recorders in the 1960s; and, more recently, the move from celluloid film to videotape as a recording and playback material, which began in a small way in the 1970s before progressing to digital in the 1990s.

Before examining any of these developments in detail, however, a word of warning is necessary. Technology may be definitional to cinema but it is not for that reason all-determining. Cinema technology did not develop in a vacuum or as a self-sustaining process whereby clever inventors devised ever-more ingenious machinery with which to advance towards a predetermined goal. The goal changed from time to time and place to place, and whether it was achieved depended on factors other than the qualities of the technology itself. There were many inventions made in the early days of cinema which lay fallow for a long time and only came into use many years later when a commercial opportunity presented itself for their application.

Nor is development always progressive. A gain in one quarter might be a loss in another. The film stock in use in the early days of cinema was very functional for most purposes but was quite uneven in its representation of the grey scale; it was, for example, totally insensitive to red light, obliging film stars to wear light grey lipstick if their lips were not to show up black. The new panchromatic stock introduced by Kodak in the early 1920s resolved the problem of rendering the grey scale but was much slower. Either stronger lights had to be used or the lens aperture had to be opened up, with the result (known to every amateur photographer) that it became impossible to maintain sharp focus on foreground and background objects simultaneously. This was fine for studio close-ups but no good for outdoor work on a cloudy day. It therefore worked to the advantage of romances and the

detriment of westerns and contributed more generally to driving film-making indoors, where it was largely to remain until the 1940s and beyond.

It is also the case that most of the major innovations discussed in this chapter were costly to introduce and were pioneered and exploited by the big studios, giving them a head start over independent producers and exhibitors who could not afford the expenditure. Technical advances which were advantageous to the makers of small and inexpensive films were relatively rare. The synching of a lightweight camera to a lightweight sound recorder which gave rise to cinéma vérité around 1960 (and also helped the French New Wave) would be one example, as would be the hand-holdable digicam. But the main trend has been towards increasing complexity in the service of enhanced spectacle, and it is this that has continued to give cinema a privileged place as a source of popular mass entertainment even in the age of multimedia.

Making images move

The story of what became cinema begins around 1890, when inventors in France, Germany, Britain, and the United States began seriously to put their minds to the business of the photographic reproduction of the effect, or illusion, of movement. It had already been shown that the human perceptual apparatus could locate such an effect when a series of similar images was passed in front of the eye in rapid succession. (This effect went under the name 'persistence of vision', but is now known to involve the brain at least as much as the eye itself.) The problem was how to create the effect with images which were photographic and drawn from life itself.

Of early cinematic devices the most immediately successful was that of the brothers Louis and Auguste Lumière in France, first shown to a paying public at the Grand Café in Paris on

28 December 1895. Prior to that, the great American inventor Thomas Alva Edison had shown moving photographs, but they were viewed as a peepshow, not projected in front of an audience. The Lumières' versatile package of camera and projector (sometimes the same machine could perform both functions and even serve as a developing tank for the film) was an instant success. Within a few years Lumière cameramen were touring the world, both showing films they had brought with them and shooting more films to take back to France. By the turn of the century, Lumière films and those of their main competitors such as Edison in the USA and Pathé in France had been displayed not only throughout Europe and North America but as far afield as Bombay, Tokyo, and Buenos Aires.

The first Lumière films were moving snapshots of everyday events happening in front of the camera—a train entering a station, workers leaving a factory at the end of a shift, a baby being fed—and were no more than fifty seconds long. The chief drawback of the Lumière camera was the clumsy way in which the roll film was jerked through the camera and projector, putting severe pressure on the film itself. This did not matter too much in shooting but in repeated projection, particularly when films got longer, the film could easily tear. A simple invention, credited to Woodville Latham in the United States and R. W. Paul in Britain, and consisting of a small loop created in the passage of the film through the projector above and below the shutter, quickly obviated that risk. Further refinements followed and it is safe to say that within a few short years, from 1895 to 1900, the technological basis of what was to become cinema had been laid.

One further problem was that of the speed at which films were to be shot and projected. Anything slower than 16 f.p.s. (frames per second) made the intermittent action of the projector uncomfortably visible, and in the 1920s speeds were gradually raised to 20 f.p.s. and above before being standardized at 24 f.p.s. with the coming of sound in 1930. Combined with a shutter on the

projector which closed briefly in the middle of each frame as well as between frames, the 'flicker effect' more or less disappeared from regular cinema projection by the mid-1920s.

Sound

The cinema up to around 1930 is generally referred to as silent. In fact there was always sound in the cinema, but it came from the auditorium, not from the film itself. The projector hummed, a pianist strummed. There might even be an orchestra. There were off-screen sound effects. And in the early days a lecturer or 'barker' was often on hand to explain the action. (This custom persisted in Japan well into the 1930s where the *benshi*, as they were known, provided not only a running commentary but voices for the principal actors.) What was missing was actual live speech.

It was not in principle hugely difficult to synchronize the action of the films with recorded speech or voice. Indeed, Edison had already achieved this back in the 1890s. But the acoustic recording in use until the mid-1920s did not produce sound loud enough to be heard in a large movie theatre. The introduction by the music industry of electrical sound recording and amplified playback (itself in part a by-product of radio) changed the situation dramatically. On both sides of the Atlantic new attempts were made to harness electrically recorded sound to film. The Americans got there first—not because their technology was superior but because they were better equipped to exploit it industrially. In 1926 Warner Bros. synchronized a music track recorded on disc to a film projector, and the following year used the same technology to produce the first 'talking picture', *The Jazz Singer*, in which there were not only songs but a few lines of speech, immortalized in the words spoken by Al Jolson: 'You ain't heard nothing yet.' Meanwhile a rival studio, Fox, had acquired patent rights to a more reliable German technology which converted sound waves into light patterns to be read by an optical sensor on the film projector. The market was then carved up, with

German and Dutch manufacturers supplying sound equipment throughout Europe while American companies controlled their home market. By 1930 cinemas across North America and Western Europe were almost all equipped to play soundtracks using the new sound-on-film technology.

The introduction of recorded sound had various knock-on effects, some major, some minor. At the human level it made several thousand theatre musicians redundant, right at the beginning of the Great Depression. Some actors also became redundant because they were thought to have voices or accents unsuitable for the new talking film. (The 1952 MGM musical *Singin' in the Rain* offers a delightful parody of a silent film star screeching hideously into a microphone concealed in a vase of flowers.) On the technical side, the running speed of cameras and projectors had to be standardized. Meanwhile the practice of tinting and toning prints for colour effects had to be abandoned as the colour interfered with the sensors reading the soundtrack, so all films in the 1930s, apart from a few in Technicolor, were strictly black and white.

Most importantly, sound drove film-making back into the studio as it was not easy to record dialogue on location. Talkies became very stagey and talky indeed. It took the development of dubbing and advances in microphone and recording technology before cinema acquired the ability to create natural-sounding dialogue in other than tightly controlled conditions. Cameras had to be soundproofed and lights devised which didn't hum during shooting. The microphone had to be connected by cables to a very weighty piece of equipment for the optical sound to be recorded, and it took nearly forty years before the umbilical cord was broken and camera and recorder could be synchronized by an electronic signal alone. It was then a further twenty years before the microphone could be separated from the recorder with actors being body-miked and able to conduct dialogues on location at some distance from the camera. It is now commonplace (though it

can be disconcerting) to hear dialogues spoken by characters who are patently out of earshot of the camera but have been brought closer either by body-miking or (more often) by dubbing.

Sound also provided a breathing space for beleaguered film industries in Europe and elsewhere since audiences wanted to hear dialogues in their own language. For a brief while the practice developed of making two or more versions of a film, shooting the same script in front of the same sets but with different actors for the different languages. This could have strange side effects. In the early multilingual film *Cape Forlorn*, a scene (preserved in the British Film Institute's film archive) in which a lighthouse-keeper learns of his wife's adultery with a shipwrecked sailor is played in the German version with intense tragic overtones, in the French version as comedy, and in the English version as straightforward embarrassment.

Multilingual, or at least bilingual films continued to be made in Hollywood for the Latin American market well into the 1940s, but in Europe the practice died out with the development of dubbing techniques in the mid-1930s. Dubbing of foreign films is now almost universal in all countries or language-areas where the market is large enough to justify the expense of producing a new sound track, and many Hollywood films are exported with an M&E (music and effects) track already recorded, leaving only the dialogues to be added locally in the studio. Dialogues can of course be altered in the dubbing, for censorship or related purposes. This happened in the 1930s in Fascist Italy, and still happens today, though usually for less sinister purposes.

Colour

Throughout the early period, almost all films were shot on monochrome stock, generally black and white. But colour of one kind or another was regularly added in the post-production process or in printing. This usually took the form of toning or

tinting the print with a single overall colour effect, but it was also possible, though elaborate, to apply multiple colours either mechanically or by hand. What was much harder to create was a functioning system for rendering the full colour spectrum direct from life. Various experiments were tried, but it took time for them to become commercially viable. Basically there were two methods for doing this. Either the colours could be recorded separately and brought together on the print, or different layers of emulsion, each sensitive to a different primary colour, could be combined on a single strip on the original shooting stock. The former was the line pursued by the American company Technicolor, which was to dominate colour cinematography from the late 1920s to the mid-1950s and beyond. The latter, which eventually prevailed, was an application to cinema of principles originally designed for still photography, and was developed by Eastman Kodak in the USA, Agfa in Germany, and other manufacturers of film stock.

The Technicolor system, which took a long time to perfect, worked by splitting the beam of light entering the camera so as to create three separate monochrome master negatives which could be recombined in printing by a process known as dye transfer. The great advantage of the process was that it was extremely stable, since the black-and-white masters, if preserved, did not fade and could be used to make new prints many years later. But there were disadvantages too. It was essentially a studio process, with a camera that was expensive, heavy, and not easy to manoeuvre. Technicolor negative stock was extremely slow and powerful lights had to used in the studio to make sure there was enough of it to produce an adequate image. Outdoors, too, there had to be plenty of light and no distracting shadows, which the three negatives could not pick up accurately.

Technicolor was not, and was never really intended to be, a realistic rendering of the world as seen in ordinary life. Its first uses were for spectacular films—costume pictures, epics,

musicals—to which its highly saturated colours were ideally suited. It was also, as Walt Disney quickly realized, perfect for animation, where the colour could be most easily controlled and could be applied in large blocks. In the mid-1930s Disney briefly held an exclusive licence for the use of the process. When that expired the other Hollywood studios, notably Warner Bros., all converted to Technicolor, though some animators elsewhere used home-grown processes.

Then, in the early 1950s, Eastman Kodak introduced a professional-grade monopack negative stock called Eastmancolor, with three layers of emulsion bonded together, each sensitive to a different primary colour. Not only was this much easier to use than three-strip Technicolor, it was also faster, less expensive, and far more sensitive to gradations of colour, and it soon superseded Technicolor as a negative stock. Its main disadvantage was that it was prone to fading—a fact which only came to light some years later, when films retrieved from the archives were discovered to have lost much of their original colour.

Eastmancolor did not instantly kill off Technicolor, which continued to be preferred as a printing process. Nor did it immediately put an end to black and white as a medium. Black-and-white negative stock was still significantly faster, quite a bit cheaper, and better adapted to night-time filming on location. Most of the films of the European new waves between 1958 and 1965 were in black and white, which was also for a long time considered to be more suited to realist subjects.

Widescreen and stereo sound

The size and shape of cinema film were decided upon right at the beginning and remained basically unchanged for half a century. The standard size (or gauge) chosen by both Edison and the Lumières was 35 mm, based on using Kodak 70 mm roll film and splitting it down the middle. This has remained the standard for the vast

majority of commercially released films ever since. The frame size was also very soon settled at approximately 24 mm × 18 mm, giving a 4:3 or 1.33:1 shooting and projection ratio. A minor adjustment took place with the coming of sound when the Academy of Motion Picture Arts and Sciences in Los Angeles decreed a new 'Academy ratio', fractionally wider at 1.37:1, for projection purposes. This then became the new standard for a further twenty years.

Throughout the silent period, various experiments had been conducted with wider gauges and ratios to achieve a more panoramic effect, but none of them caught on. For his epic *Napoléon* in 1927, the French director Abel Gance lined up three cameras and three screens side by side. The effect, though imperfectly realized, was undoubtedly spectacular, but the expense of a system that was unusable for everyday exhibition bankrupted the producers.

No such mistake was made when new widescreen ratios were launched a quarter of a century later. In the early 1950s the film industry was becoming increasingly alarmed by the inroads that television was making into the film audience. Since TV at the time only offered a small, squarish, black-and-white (or grey-and-white) image and tinny sound, the obvious solution was to trade on cinema's potential for spectacle. From 1952 onwards a number of innovations were tried out, first in the USA and then worldwide. There was Cinerama, which offered a massive image on a curved screen filling the spectators' entire field of view, but requiring special theatres to show it in. There was a brief vogue for films in 3-D, which involved spectators donning special glasses to obtain a stereoscopic effect. Neither of these had much impact on mainstream viewing, and neither have their successors such as the IMAX or the renewed fad for 3-D in the early 21st century.

One new format, however, had a wider effect across the board. Introduced by 20th Century Fox in 1953, CinemaScope exploited a

device invented by the Frenchman Henri Chrétien to which it had acquired patent rights a quarter of a century earlier. This was the so-called anamorphic lens, which worked by vertically squeezing the image in the camera, enabling it to take in a wider field of view on a standard 4:3 frame (see Figure 1). A similar lens on the projector then unsqueezed it, producing an image more than twice as wide as it was high. (The screening ratio adopted by Fox was 2.35:1, spectacularly wide but still leaving room on the print for an added soundtrack.) Although it involved a lot of remodelling of theatres to accommodate the wider screen, CinemaScope was an instant success. Other companies either sub-licensed it or devised alternative screen-enhancing processes of their own.

The first uses of CinemaScope were for colour spectaculars. But it could also be used for modestly budgeted films in black and white. Looking at the first CinemaScope films, the future directors of the French New Wave, led by François Truffaut, declared that the point of the new, wider screen ratio was not spectacle but the integration of space. Beginning with Truffaut's own first feature film, *Les Quatre Cents Coups* (1959), many other early French New Wave films (by Jean-Luc Godard, Jacques Demy, Alain Resnais, and Truffaut himself) were shot anamorphic, most of them in black and white.

Alongside the new wider screen, the studios introduced stereophonic sound. This, too, was not a new invention. Recording engineers had been experimenting with it for years and, in cinema, Disney had made an abortive attempt to produce a stereo soundtrack for *Fantasia* in 1944. Again the stimulus to its introduction was competition, this time from the record industry. Throughout the 1930s and 1940s cinema had offered the possibility of a much better sound experience than could be obtained on a domestic radio or record-player, but the introduction of the long-playing vinyl record around 1950, first in mono and then in stereo, threatened this precious advantage, forcing film companies to react.

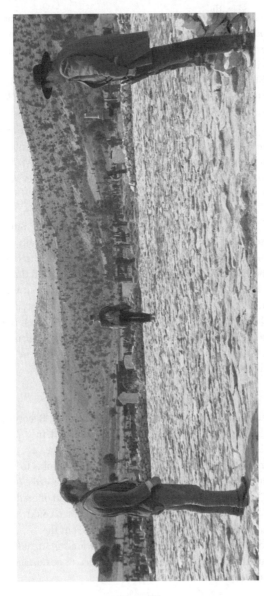

1. The final shoot-out in Sergio Leone's widescreen western *The Good, the Bad and the Ugly* (1966), with (left to right) Eli Wallach, Clint Eastwood, and Lee Van Cleef.

The main problem with CinemaScope, and its numerous clones such as Franscope and Dyaliscope in France, Totalscope in Italy, and Tohoscope in Japan, was that although they broadened the image and made it more spectacular, they did not improve its quality and indeed reduced it, as the larger image was still contained within the traditional 24 mm × 18 mm frame. One way of making the frame area larger, adopted by the Paramount studio for their VistaVision process, was to run the film horizontally through the camera as was done in 35 mm still photography. This provided a much better negative, but the film still had to be projected in the normal way. The alternative was simply to double the gauge of the film. The late 1950s saw the introduction of various processes which culminated in the projection of spectacular films in 70 mm in selected theatres in big cities, with the print scaled down to 35 mm for less prestigious locations.

Meanwhile some of what had appeared to be problems with the original CinemaScope faded away or were resolved by technical improvements of one kind or another, such as a new generation of superior Panavision lenses and more sensitive film emulsions. After a brief period of frenetic innovation things settled down. Ultra-wide ratios went out of fashion (partly because films were now regularly rescreened on television where the screen continued to be in 4:3 and could not comfortably accommodate wider ratios). With the aid of the new fine-grain emulsions, the 24 mm × 18 mm frame proved capable of holding more information than had previously been thought, and it even became possible and indeed regular practice to achieve adequate widescreen effects with standard frames masked top and bottom to give ratios of 1.66:1 or 1.85:1. A revolution in image quality had taken place, and in sound quality too with the introduction of multi-track Dolby Stereo in the 1970s. But in one respect at least it was back to square one, with the 35 mm gauge and 24 mm × 18 mm frame remaining standard for all but the most spectacular films, as in the days of Edison and the Lumières.

Animation and special effects

In the cinema, what you see is not always what you think you are seeing. That giant ape on top of the skyscraper is not really an ape, nor is the skyscraper a skyscraper. As for the woman cradled in that giant simian hand, she really is the actress Fay Wray (or a photograph of that actress), but she was only ever in the studio. All the rest was trick work, alias special effects.

The use of special effects, as they came to be known, is as old as cinema itself, or even older. But in the early days, as for example in the trick films of Georges Méliès around 1900, they were used to delight rather than to deceive—or if to deceive then to deceive only in the way conjuring tricks deceive.

From the early 1920s onwards, however, more sophisticated forms of special effect came into use as part of the necessary armoury of film-makers working in the feature film industry. Sometimes, as in the example from the original 1933 *King Kong* (Figure 2), effects were needed in order to represent something that could not exist in real life, such as a monster on top of a skyscraper. They could also be used to show something that could and indeed did exist but was difficult to film in situ. Mostly, however, they were used to save money. Thus a second-unit film crew could be sent out to film a remote landscape, and the material they brought back could be back-projected in the studio while the expensively hired actors performed suitable dialogue in appropriate dress in front of it. More elaborately, in the mid-1920s the great German cinematographer Eugen Schüfftan devised a process whereby miniature sets could be photographed through the unscraped part of a partially scraped mirror set at an angle to the action. Schüfftan used this process to brilliant effect in 1927 in Fritz Lang's classic film *Metropolis*, thus avoiding the enormous cost incurred by the American D. W. Griffith in constructing life-size sets for the Babylonian sequence of *Intolerance* in 1916.

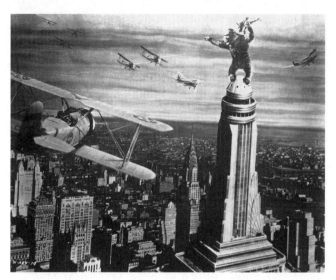

2. *King Kong* (1933).

The Schüfftan process was used in many films throughout the
early sound period, including *King Kong*, but eventually fell out of
use, though it was revived by Peter Jackson for *The Lord of the
Rings: The Return of the King* in 2003.

What replaced the Schüfftan process, particularly for colour
film, was the travelling matte, a two-layered form of painted
design which could be used as a moving backdrop behind the
main action. This is a striking example of the overlap between
animation and so-called live action, often regarded as an
antithetical form of film-making. (Not only is the travelling matte
a form of animation, but so is the frame-by-frame manipulation
of the model monster in *King Kong*.) There is indeed, and always
has been, a continuum stretching from simple photography of
things in the world, via special effects cinematography, to
animation proper.

Film animation, like trick photography, is as old as cinema itself, and, like everything else in cinema, developed in contrasting ways. Its scope ranged from simple line drawings that mysteriously sprang to life, as in the 'Out of the Inkwell' series by Max Fleischer between 1918 and 1929, to the quasi-naturalism of some modern animated films. Production methods differed too, from the patient solitary model work of Władysław Starewicz in Europe to the giant factory in which Disney's underpaid 'in-betweeners' laboured to execute others' designs (and were driven to take strike action in 1941).

To avoid the need to paint or draw every detail of every frame singly, animators developed a system that used transparent sheets of celluloid called cels, which could be overlaid on each other so that Bambi could frolic in front of a forest which, having been drawn once, didn't have to be redrawn time and time again. In the golden age of animation from 1930 to about 1960, devices such as the rotoscope, invented by Max and Dave Fleischer, and then Disney's multiplane camera enabled sophisticated three-dimensional effects to be created. But they were expensive and eventually gave way to simpler methods for most purposes. The last use of the multiplane was for *The Little Mermaid* in 1989. After that digital took over.

Digital

The digital revolution has affected cinema at every level, from production to exhibition, at the periphery and at the centre, and, some would say, in its ontology. The essence of cinema, it has been argued, lies in its ability to capture reality in the form of a physical imprint. Light from outside is reflected, refracted through a lens, and the quantities of light thus refracted make a mark on the emulsion without any form of intermediary agency. As we have just seen, things are not always that simple, but however complex the tampering with the image the sheer physicality of the imprint acts, at least in theory, as a kind of guarantor of the cinematic

image's relationship with reality. Digital puts this relationship into question since there is no longer any imprint, only a record expressed as a series of binary numbers. If the record is not tampered with, the digital record can be as truthful as the analogue one. But since it is so easily tampered with and the tampering itself does not necessarily yield a trace, trust in the film image can never be the same.

Whatever one makes of this argument, it is undoubtedly the case that digital has made playing with the photographic image in editing and post-production much, much easier. Over the past twenty years computer-generated imagery (CGI) has all but eliminated the cumbersome special effects of yesteryear. So it's farewell to King Kong and to Bruce the animatronic shark from *Jaws*. In their place come creatures which never had a physical avatar but were only ever generated on a computer.

Digital also makes it much easier for the editor to call up different takes and put together a rough cut. Films can still be shot on celluloid and be printed on celluloid for theatrical projection, but all the intermediate work is done digitally. Digital makes possible the shooting of an entire 90-minute film in one take, as achieved by the Russian director Alexander Sokurov with *Russian Ark* in 2002. Digital projection means no more scratchy prints laboriously loaded on to the projector. Some cinematographers do not like it since it is hard to avoid the 'video game' look imparted by digital, and specialists regret the poor contrast of digital 'prints' of black-and-white classics. But digital has so many advantages across the board, for makers of low-budget films as well as high-end productions, that it is likely within a few years to have replaced celluloid entirely for all but very special purposes.

Outside the mainstream

From very early on, outside the world of commercially released films there existed a thriving world of amateur and small-scale

film-making and projection, using various gauges between 19.5 mm and 8 mm. But for anything publicly projected, including documentary and newsreels, 35 mm was *de rigueur*. From the 1930s onwards, however, a 'sub-standard' gauge of 16 mm became increasingly popular for non-theatrical projection purposes. The cellulose acetate base of 16 mm stock was less perfectly transparent than the cellulose nitrate in use in commercial cinema but had the immense advantage of being non-flammable and exempt from some of the stringent safety regulations surrounding 35 mm projection. The 16 mm format was also more manageable and in the 1950s began to be adopted for television newsgathering. This was fine if the only sound required was a dubbed-on commentary, but live sound on 16 mm was as cumbersome as for 35 mm. The solution came around 1960 with the more or less simultaneous development of a silent-running, lightweight 16 mm camera, the Éclair Caméflex, and an equally silent and lightweight tape recorder, the Nagra III, to which the camera could be synchronized. The Éclair–Nagra combination revolutionized documentary and gave rise to a completely new school of documentary film- and TV programme-making known variously as direct cinema and cinéma vérité. It also gave a boost to the freewheeling style of low-budget feature films typified by the French New Wave. Further refinements followed in the 1970s. An even lighter camera, the Aaton, came into use and the frame area on 16 mm negative stock was enlarged, improving image quality, while a device called the Steadicam made one-person operation wobble-free even with a 35 mm camera. Nowadays, though, to make a film or TV programme really cheaply, all you need is a low-end digital camera, maybe some lights, a home computer, and output on to DVD or the small screen. And, of course, a modicum of talent.

Ambiguities of progress

Do all these developments represent progress? As already suggested, gains in one quarter are often losses in another.

Industrial and artistic factors intervene, as do changes in audience tastes.

Some technological advances of great importance to the industry pass almost unnoticed by the ordinary spectator (how many people care, for example, if a film in a theatre is a celluloid print or projected from a hard disk or even a Blu-ray?). Some are welcomed by parts of the audience but rejected by others. Of the technological changes discussed in this chapter, only a handful are of unquestioned and permanent importance. I would single out four: smooth projection (by the 1920s), synchronized sound (from 1930), colour (almost universal from the 1960s), and the possibility of viewing films to quasi-cinematic standards in the home (1990s onwards). There are also more subtle developments, such as the steady improvement in film emulsions and their digital counterpart, and outside the mainstream the introduction of lightweight cameras and sound recording equipment from the 1960s onwards was to produce a small revolution of its own. But for much of the rest, you can take it or leave it.

Chapter 3
Industry

The cinema is an industry. It is not, as the writer and film-maker André Malraux airily declared, 'par ailleurs' (also, moreover) an industry. It is an industry through and through and its character as an industry forms part of its basic definition. Since the 1920s this industry has been highly monopolized, but even outside the monopolized core the production and circulation of films for public exhibition takes place of necessity within some sort of industrial framework. But cinema did not become an industry overnight, nor did it do so as an automatic consequence of its technological base. The technology used by early cinema was fairly primitive. It had two sophisticated components, the film stock and the lenses. But apart from the French company Pathé, which manufactured its own stock, most film enterprises from the Lumières onwards bought their stock from Kodak, while for camera and projector lenses they could rely on existing manufacturers such as Zeiss in Germany and Bausch & Lomb in the United States. Most of the rest of what film-makers needed could be put together in an artisanal workshop.

What set cinema on the road to becoming an industry in the early years was the needs of commerce. The new medium spread rapidly across the globe, at first wherever a site could be found but increasingly in dedicated venues (known in the United States as nickelodeons). Premises had to be acquired, orders processed,

offices opened in foreign cities. The business was barely regulated and often cut-throat. Internationally the main competition was between the United States and a handful of European countries led by France (initially the Lumières but increasingly Pathé-Frères and Gaumont) and Denmark (Nordisk), with Italy a late entrant. Britain was an insignificant producer but London was important as a distribution exchange. With a view to cornering the domestic market in the United States, the inventor and entrepreneur Thomas Edison mounted a vigorous campaign of litigation against his competitors to enforce his (often dubious) patents on various pieces of camera and projection equipment, following this up in 1908 by the formation of a Trust, the Motion Picture Patents Company, based on acceptance of his claims. Most film companies joined, but some went under, while a handful of survivors struggled on as an independent consortium. But the Trust could not stop exhibitors continuing to import films from Europe, and Pathé and Nordisk remained unaffected and for a while even increased their market share in the United States.

If one were to view the state of affairs around 1910 in terms of a contest between Europe and the United States it might have best been described as a state of precarious equilibrium, with the balance if anything tilted in favour of the Europeans who were beginning to produce longer and more adventurous films verging on what were soon to be described as 'features'. But in a few short years a revolution was to take place which would transform American cinema decisively into a fully fledged industry, and in so doing set it on the path towards a world domination which it has retained ever since.

What started the revolution was the decision by a number of film-makers and entrepreneurs to relocate from the East Coast of the United States to southern California—or more precisely to the western suburbs of the city of Los Angeles in and around the small township of Hollywood. They did so for a variety of reasons—the varied landscape, the abundant sunshine, the availability of cheap

real estate and non-unionized labour, and the distance from the headquarters of Edison's Trust, which they soon successfully outflanked.

The Hollywood studio system

The first innovation of the 'independents', as they were initially called, was to invest in the making of longer films on the European model. For this they needed money, which they mostly raised on the East Coast, where they already had business connections. The second, which took longer to achieve, was to structure their businesses as vertical monopolies, with the same companies, or groups of companies, producing films, distributing them nationwide, and for preference exhibiting them in theatres attached to the same companies as produced and distributed them. Meanwhile, production was rationalized on factory lines, with work scheduled so that as soon as one production had finished on the lot, another was ready to take its place, ideally reusing the same or barely modified sets.

Neither the system of vertical monopoly nor the factory-style production methods was entirely new. Both had been pioneered in France, first by Pathé and then by Gaumont (where production was for a while in the hands of one of the first women film-makers, Alice Guy-Blaché). But the scale and efficiency of what was done in the United States from the 1910s onwards was, and has remained, unparalleled. It also took some time for the system to consolidate, which it did by means of mergers, takeovers, and, on occasion, dynastic marriages, offset by occasional defections of key players. By the mid-1920s the system was fully in place, and a handful of companies had emerged which between them controlled the major part of what its propagandists claimed to be by then the fourth largest industry in the United States. The system has become known as the studio system, after the premises on which its films were shot and edited, but in fact the real power lay not in the California studios but in the corporate HQs

(generally in New York) where decisions were taken in the collective interests of the three branches of the business—production, distribution, and exhibition.

The major studios in the 1920s were Paramount, MGM, Fox (later 20th Century Fox), and Universal, with Warner Bros. coming into its own towards the end of the decade, and Columbia and RKO (Radio–Keith–Orpheum) only in the 1930s. Slightly to one side stood United Artists, which had been formed in 1919 as a breakaway by leading stars Charlie Chaplin, Douglas Fairbanks, and Mary Pickford who did not wish to be dictated to by studio executives. Unlike the other big studios, United Artists did not have many guaranteed outlets for its production, which was in any case sporadic. So although it produced major hits such as Fairbanks's *The Mark of Zorro* (1920) and Chaplin's *The Gold Rush* (1925), it was soon forced into a position of dependency on the other majors for effective releasing (see Figure 3).

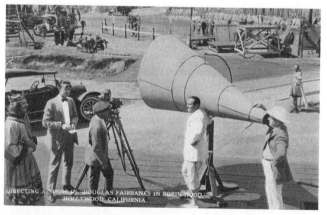

DIRECTING A SCENE IN "DOUGLAS FAIRBANKS IN ROBIN HOOD" HOLLYWOOD, CALIFORNIA

3. Production still from the shooting of the 1922 film *Robin Hood*, starring and produced by Douglas Fairbanks and directed by Allan Dwan.

Meanwhile the major studios continued to consolidate. Paramount, headed by Adolph Zukor, was the largest, by 1925 absorbing under the Paramount label the producers Famous Players–Lasky and various exhibition chains, including the luxurious 'Roxy' picture palaces and the Chicago-based Balaban & Katz (the first to introduce air-conditioning in its theatres). Its great competitor was MGM, formed in 1924. The initials in its name are those of *M*etro Pictures, Samuel *G*oldwyn, and Louis B. *M*ayer, but Goldwyn broke away from the company to become an independent producer. The real power behind the throne, however, was the exhibition entrepreneur Marcus Loew, who is commemorated not in the company initials but by the fortunate coincidence of his name with that of company symbol, Leo the Lion, inherited from Goldwyn.

Surrounding the roaring lion on the famous MGM opening credit was the company slogan 'Ars Gratia Artis'—art for art's sake—and MGM was the most vigorous of all the studios in its pursuit of the upmarket and upscale audience. Scholars have often puzzled over the 'embourgeoisement' of what in its origins had been a low-class form of entertainment, but the reason is not far to seek. Middle-class spectators may have been fewer in number but they paid more. Hollywood studio films were mostly first released in prime locations where seats could cost up to $2, and then found their way downmarket to working-class areas where they cost 25 cents or less. Films were therefore targeted at the more affluent first-run audience, with the less affluent a secondary consideration.

Not that the audience at large was entirely neglected. Films were still made for all of America—or to be more precise all of white America, with a small separate industry growing up to cater for black audiences—and for anyone at home or abroad who was prepared to buy in to the broad set of values that 'Hollywood' increasingly came to represent.

In theory the system functioned as a virtuous circle, with exhibitors providing crucial feedback on audience responses as

well as box office figures to guide the studio in its choice of films to put into production for the following year. The studios also could afford to lose money on the occasional expensive miscalculation on a mega-production, as MGM did with *Ben-Hur* in 1925, since these losses would be offset against consistent profits elsewhere.

But what suited the studios and, to a great extent, the ever-growing audience did not suit everybody. Independent exhibitors objected to the procedures of block- and blind-booking whereby the major distributors forced them to take, sight unseen, a slate of films they didn't necessarily want in order to get their hands on popular hits. Independent producers found it hard to get finance for productions for which those same distributors would not give them a guarantee of wide release. Above all it was artists who felt demeaned and exploited by the system. This was a highly Fordized industry, but what it produced was not Model T Fords but art works dependent on very particular talents if they were to continue to satisfy an increasingly demanding public. Balancing the needs of formula and teamwork with the inspiration that only gifted artists could provide required a special talent in itself, and only a handful of producers and executives such as Irving Thalberg at MGM and the independent Samuel Goldwyn possessed it. Sometimes the demands of recalcitrant artists were extreme, and Thalberg had to step in to decisively reduce the rough cut of Erich von Stroheim's 1924 film *Greed* from an intended ten-hour length to a more reasonable two-and-a-half hours to make it releasable.

The most crucial talent, however, was that of the stars, and it was when they too began to rebel that the system most clearly revealed its oppressive character. In 1934, Bette Davis was taken to court by her employer, Warner Bros., for accepting work outside the studio during a fallow period when the studio was not giving her any roles she thought she deserved. Although Davis lost the case, her fight attracted a lot of sympathy both within the industry and among the public at large and led to a widespread easing of

contractual terms in the years that followed. Complaints from writers, meanwhile, could easily be brushed aside in the early sound period as mere petulance. Their contracts might be oppressive but, after all, they were still better paid by the studios to furnish lines of dialogue than they would be as novelists or playwrights.

By 1938 the monopoly practices of the Hollywood industry had begun to attract the attention of the US Department of Justice, which initiated proceedings against Paramount on behalf of the independent exhibitors. The case was not satisfactorily concluded and the war supervened, but after the war the Justice Department returned to the attack and, in a landmark decision by the Supreme Court in 1948, Paramount and the other studios were forced to divest themselves of their theatre chains and bring to an end the practices of block- and blind-booking of studio films.

At the same time, for reasons of their own, the studios began to open up the system on the production side. Independent producers, particularly those with family connections to the heads of studios, had always enjoyed a certain freedom of action and in 1935 Louis B. Mayer's son-in-law, David O. Selznick, formed his own production company. He scored early successes in 1937 with *A Star is Born* and *Nothing Sacred* (with Carole Lombard), but his greatest triumph came in 1939 with *Gone with the Wind*, the biggest grossing film in Hollywood to date. Selznick's career continued after World War II with films like *The Third Man* (1949—in conjunction with Hungarian-born British producer Alexander Korda). After that his star began to wane, but by this time the system had loosened up considerably and many other independent production companies had entered the fray, with directors such as Howard Hawks and Otto Preminger often acting as their own producers, and stars such as Burt Lancaster fronting their own production companies to obtain tax advantages as well as the opportunity to manage their own acting careers.

Europe and Asia

While Hollywood put together its studio system, Europe was in the grips of World War I, with film production severely curtailed. When that war ended, a deluge of American films flooded into European markets, distributed with the aid of the same strong-arm methods of block- and blind-booking used by the Hollywood studios at home. Within a few years the Americans had captured between 50 and 80 per cent of the market in most Western European countries. Germany was spared the worst of the deluge, but only because post-war hyperinflation made the German market a risky place for foreign capital to invest in. By the time the situation stabilized around 1924, the German film industry had recovered sufficiently from the effects of war to be able to offer films which attracted the public at home and abroad, with Fritz Lang's dystopian science-fiction epic *Metropolis* in 1927 a prime example. Elsewhere film industries were on the verge of collapse. It was only through co-production agreements with German companies that the French cinema was able to revive in the mid-1920s. In Italy production ceased almost entirely throughout the 1920s, and in November 1927 no new British films were in production at all.

In an attempt to stave off the flood of imports, various European countries, with Germany in the lead, imposed limits on the number of foreign films that could be imported in any given year. In a parallel initiative, the British Cinematograph Films Act of 1927 specified that a certain proportion, or quota, of all films released in Britain had to be British made. The move backfired, since what happened was that the American studios set up production facilities in Britain churning out cheap films known as 'quota quickies', which appeared in cinemas, if at all, only as unnoticed second features in a double bill.

Protection was at best a palliative. American films were not only more effectively marketed, they were also consistently better

produced than European films and more attuned to post-war popular taste. They were modern in a way that appealed to sections of the intelligentsia as well as to the mass public. They had high production values without necessarily having cost all that much to produce, and they had usually covered their costs on the home market and could be offered for export at knock-down prices.

More than just protect themselves, industries outside the United States needed to be able to compete, both in industrial efficiency and in market appeal. One by one, countries that were in a position to do so adopted some or other aspect of American practice, whether it was industrialized production, vertical integration, or slick modern content. One of the first countries to respond was Japan, where a devastating earthquake in 1923 had destroyed the premises of its leading studios. The response was not only physical reconstruction but a thoroughgoing modernization of the industry along American lines. Content, however, remained for the most part resolutely traditional. Elsewhere the response was slower and varied in its effectiveness.

Alongside Germany, Britain was among the first countries in Europe to modernize its industry on the American model. The 1927 Films Act had opened the way to consolidation and vertical integration, and a duopoly of ABC and Gaumont British (later Rank) was soon established, covering the three levels of the business: production, distribution, and exhibition. The new monopolists constructed or refurbished studios in a wide arc to the north and west of London, with the largest, Pinewood, opening in 1936. Impressive Egyptian-style cinemas were built in the burgeoning suburbs on the periphery of major cities. The Rank/ABC duopoly was to remain in operation for many years, even after the Paramount decision had outlawed similar practices in the United States. The predictable effect was to stifle competition. It offered British filmgoers a choice of British and

American studio films, with the public tending to prefer the more glamorous American product.

In Italy the Fascist government had been slow to react to the near destruction of the native film industry, but when it did it acted decisively. Luigi Freddi, nominated by Mussolini in 1934 as head of the semi-nationalized film industry, visited Hollywood and took away many useful lessons. He commissioned the construction of the massive Cinecittà studios outside Rome, which opened in 1937, and inaugurated the production of Hollywood-style popular comedies and melodramas. A convinced Fascist, Freddi nevertheless tried on the whole to keep politics out of his film production policies and concentrated on the economic aim of making Italian films as attractive to the various strata of the Italian public as their American equivalents. In this Freddi was quite successful, but never enough to prevent the public from indulging in a dream of America as a land of promise to which in the 1930s they were no longer free to emigrate.

Although the French also invested in production facilities in the early sound period, in Nice as well as in and around Paris, their studios were never as well equipped as those in Hollywood, or in Germany for that matter. Nor did the French succeed in rationalizing their industry overall on the American model. Throughout the 1930s and indeed beyond, France had a plurality of production companies and independent exhibition outlets, which contributed to making French cinema more varied than that of any other advanced country.

Imitation of American practice sometimes took place even where there was no commercial competition to fight off, as for example in the Soviet Union where, for a mixture of political and economic reasons, relatively few films were imported in the 1920s or beyond. But countries with completely or partially closed markets still found it worthwhile to draw lessons from the sheer efficiency of the Hollywood studios. Besides Japan, other populous Asian

countries invested in studio production to serve national, regional, or (with the coming of sound in the 1930s) linguistic markets. Shanghai was the main Chinese (Mandarin) production centre; Hong Kong made films for the Chinese diaspora both in Mandarin and Cantonese; Bombay (now Mumbai) was and still is the centre of Hindi film-making, with other cities emerging to provide films in other Indian languages such as Tamil or Telugu. Although never rivalling Hollywood in technical sophistication or sheer industrial muscle, these industries could rely on the resilience of local cultures and a preference for home-produced product to enable them to thrive well into the 21st century.

The system crumbles

By the time the Paramount Decree came into force the Hollywood system was facing a bigger threat: the loss of audiences. Spectator numbers began to decline in the USA and Britain from 1945 onwards, and in Western Europe and Japan in the 1950s. The Americans hoped that decline at home could be offset by expansion into new foreign markets and the reopening of those that had been temporarily closed off during World War II. But the Chinese Revolution and the Iron Curtain in Europe meant that markets in the Communist bloc were lost for ever (or at least until 1990), while Western European cinemas staged a strong recovery in the 1950s. Post-war exchange controls meant that profit from films in foreign markets could not always be repatriated, and the only way to get it back was by reinvesting it in film production in the country concerned. Thus arose the phenomenon of 'Hollywood-on-Tiber' whereby American films, including the 1959 remake of *Ben-Hur*, were shot in studios in Italy, with American stars and key technical personnel. (Vacant studio space in Hollywood then became available for TV production, either leased out to TV producers or, from the late 1950s, for production by the studios themselves.)

The cost of shooting *Ben-Hur* at Cinecittà studios in Rome mopped up a lot of MGM's accumulated profits in the Italian

market, while also being profitable in its own right. But a later venture, *Cleopatra* (1963), also shot at Cinecittà, was a financial disaster, and nearly bankrupted the producing studio, 20th Century Fox. By this time the studio system of the 1920s and 1930s was a shadow of its former self. Cross-ownership with the music industry and with radio, and with technology companies such as telephony giant AT&T, had already eroded the power of the film studios as such. But worse was to come. Although crumbling, the system remained cumbersome and inflexible and lacking in the entrepreneurial flair possessed by its founders in the 1920s. The audience was not only declining in numbers but segmenting itself, with the youth audience proving particularly elusive. Films designed to please everybody ended up pleasing nobody—or at any rate not enough people to make them a reliable source of profit. One by one, the great studio companies ceased to be profitable and succumbed to predatory investors. MGM was the first to go, sold to the speculative investor Kirk Kerkorian in 1969 for the sake of its 'Leo the Lion' logo. Marcus Loew held on to his theatre chain but film production was cut right back. The fate of the other studios was less dramatic, but by 1975 almost all of them had become part of the portfolio of larger conglomerates for whom film production was only a secondary interest.

As the system began to fall apart, space was created for the emergence of a new generation of aspirant directors, including Francis Coppola (*The Godfather*, 1972), George Lucas (*American Graffiti*, 1973), and Steven Spielberg (*Jaws*, 1975). At first the outsiders received only a lukewarm welcome from the studios. Coppola had to fight hard to get what he wanted from Paramount, including the leading role for the notoriously troublesome Marlon Brando, and *American Graffiti* was only taken on by Universal after the other major studios had turned it down. But both films made a lot of money, allowing Coppola to make two more films in the 'Godfather' series and Lucas to make the mega-hit *Star Wars* (1977) and its sequels. Spielberg had more of an inside path to success, though not an easy one. Hired by Universal as a jack of all

trades, in 1971 he directed a small made-for-TV thriller called *Duel* about a massive tanker-truck pursuing a motorist across the California desert. Its unexpected critical success (including a rave review from the influential Dilys Powell in the *Sunday Times*) meant he could go on to make *Jaws* in 1975, though not without many fights between the director and the studio. A 'New' Hollywood had come into being, in many respects very different from the old.

From being vertically integrated producers, distributors, and exhibitors of films, the major studios were now increasingly part of horizontally organized media conglomerates. They had already been forced to divest themselves of their monopoly in exhibition. Now they found themselves handing over more and more production to independents. This did not mean a loss of power, but the power the majors retained was focused more and more on distribution, not just of films but across the media spectrum. As a result they were better placed than they initially realized to face the challenge of home video and cable TV, which in the late 1970s began to make the same inroads into the theatrical audience as broadcast TV had done in the 1950s. In fact the new media proved to be more of an opportunity than a threat. It was the subsidiary market of 16 mm film distribution for the educational and film society market that suffered most from the competition provided by videotape (and later DVD), collapsing entirely in the late 1980s. Meanwhile video and cable provided new outlets for films that had done their run and been relegated to the archives, and in 1986 the cable mogul Ted Turner bought what remained of MGM to enable him to launch his specialist channel Turner Classic Movies, based on the studio's rich back catalogue. Not hidebound by a commitment to theatrical exhibition, the new conglomerates diversified, with Paramount's parent company Viacom investing in the music video channel MTV and the video retail chain Blockbuster. A successful first release for a major picture remained important, but thereafter the bulk of revenues came from sources other than theatrical exhibition, including the

merchandising of film-related products such as toys and T-shirts. The business as a whole remained lucrative, but only as part of a new media ecology.

Outside the studios

Films did not have to be made in studios or by studio-based companies. All or almost all of a film could be shot on location with rented equipment and costumes, and with the footage developed by a small lab and post-production done in one of the many editing suites and dubbing theatres to be found in London's Soho district and similar places in other cities. It might be hard—and often was hard—to get the resultant film released in more than a handful of venues without recourse to a major distributor, but across the globe film-making was and still is far more normally practised as a cottage industry (albeit a technologically based one) than by the studio methods pioneered in Hollywood. Since the end of World War II the majority of what are called art-house films have been made and circulated in this relatively ad hoc fashion, with a certain amount of help from the big international distribution companies.

The move to outdoor filming received an unexpected boost in 1945 when, with Cinecittà and other studio premises out of action, Italian film-makers such as Roberto Rossellini and Vittorio De Sica took to the streets to place the action of their films in recognizable real places, giving rise to the movement known as neo-realism. The neo-realist example was to be followed by film-makers in India, notably Satyajit Ray and Ritwik Ghatak. Other, more concerted movements followed suit, beginning with the French New Wave in 1959/60 and (unknown in the West) a wave of semi-independent film-making in Japan, and spreading to Eastern Europe and Latin America as the decade progressed. Only Britain to some extent bucked the trend. Directors Tony Richardson (*Look Back in Anger*, 1959), Karel Reisz (*Saturday Night and Sunday Morning*, 1960), and Lindsay Anderson (*This*

Sporting Life, 1963) were all prevented from shooting their films on location and driven back into the studio by cautious producers afraid that mainstream audiences would not take to films shot cheaply and roughly on the model pioneered by French New Wave directors such as François Truffaut or Jean-Luc Godard.

Not all European film-making followed the neo-realist or New Wave model—nor, for that matter, when bigger budgets became available, did the neo-realist and New Wave film-makers themselves. The larger European countries still had well-equipped studios and important production companies to exploit them. The Italian film-maker Luchino Visconti, who had shot his neo-realist masterpiece *La terra trema* on location in Sicily in 1947, returned to the island in 1962 for the spectacular historical drama *The Leopard*, with post-production done in Rome and financial backing from 20th Century Fox. Co-production between two or more countries also became the rule in Western Europe, so that a film like Michelangelo Antonioni's *The Eclipse* (1962) would qualify for home market protection in both France and Italy, as well as having the popular French actor Alain Delon as the male lead (Figure 4).

At least European film-makers had choices in front of them. In poor countries in Africa and Latin America—in Bolivia, for example, or Senegal—there were virtually no film-making facilities of any kind and all post-production work had to be carried out elsewhere. Film-makers from former French colonies in Africa were able to rely on assistance from quasi-governmental French sources to ship materials to Paris for editing and dubbing, and further help was available to get their films released on the international art cinema circuit. (This help was not entirely disinterested and films critical of the former colonial power were subject to interference and censorship by the French authorities.) In former British colonies the situation was the opposite. In Ghana and Nigeria there were studios and equipment but nothing was done to help films produced there get released internationally.

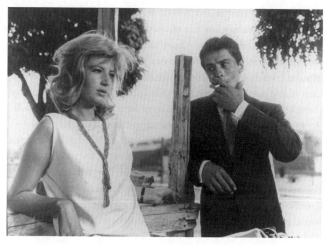

4. Monica Vitti and Alain Delon in a scene from Michelangelo Antonioni's *The Eclipse* (1962).

It was only in the 1990s that a flood of cheaply made video films began to appear in Ghana and Nigeria and found a ready market among West African communities in Britain, similar to that existing for 'Bollywood' films among British-resident Indians. By the time this happened, however, the international market for films was beginning to undergo a seismic shift and a new term came into use: transnational cinema.

Transnational cinema

Cinema has always been international and its spread across the world has been by means of international trade. As it spread, so this trade became increasingly regulated, and the promoters of this regulation were for the most part national governments, concerned about the consequences for industries within their borders of the apparently irresistible spread of one industry in particular, that of the United States. From the 1920s until 1980 or thereabouts the basic model for understanding the world film

trade was fairly simple. On the one side there was a single globally distributed cinema, known in shorthand as Hollywood, and on the other side there were the hundred or more cinemas of the rest of world, referred to generally as 'national cinemas'. America exported, while the countries of the rest of the world protected their home markets as best they could and traded modestly among themselves. The regulation of the international trade in films took the form of measures such as currency controls, tariff barriers, quotas, and the like. To be traded internationally, films had to cross borders and these borders were policed. Most of the restrictions on international trade were directed against Hollywood, and were basically economic, but there was a cultural side to them too, since Americanization ('coca-colonization' as it was sometimes called) was also seen as a threat to national cultures.

This model was never perfect. Many of the world's cinemas were decidedly subnational and some were already what we would now call transnational, and their zone of circulation was determined by language rather than by national borders. That was the case, for example, with the Yiddish cinema that flourished in Eastern Europe in the 1930s before being brutally extinguished by the Holocaust. It was also the case with the cinema of Hong Kong, a small British colony whose success was built on exports to a Chinese-speaking diaspora far more numerous than the population of Hong Kong itself. And even as late as 1990 there were still many countries which Hollywood had yet to penetrate, let alone dominate.

Despite its growing limitations, the model nevertheless held good, right up until the end of the 20th century. It was, for example, the model I adopted, albeit with some misgivings, when planning my *Oxford History of World Cinema* in the early 1990s. Even then, however, powerful forces were at work, putting pressure on the way world cinema was structured. The sources of pressure were of two kinds: trade liberalization and mass migration—flows of money and flows of people.

Liberalization of the film trade, as with that of other goods, began in earnest in the early 1990s. The nascent European Union abolished tariff barriers on media products between member states in 1991, and as part of the General Agreement on Tariffs and Trade negotiations in 1993 broadly agreed to wind down remaining limitations on the importation of American films. (Only the French objected, on cultural rather than economic grounds, but since Europe had to negotiate collectively, they obtained only token concessions, with all the other parties eager to move on.) With the collapse of Soviet Communism from 1989 onwards, practically all of Europe is now part of the same free trade zone and open to ever-more American expansion.

Trade liberalization had multiple effects, not all positive or exactly as predicted. In Eastern Europe it led to the demise of entire film industries, reduced to renting out their once flourishing studios as facilities houses for Western producers and touting the surrounding landscape as a stand-in location for similar landscapes elsewhere (the Carpathians for the Appalachians in Anthony Minghella's 2003 *Cold Mountain*, for example). Developments in East Asia did not go according to plan either. Mainland China's entry into the world market was hedged with obstacles. It led to the making of a few major co-productions with Hollywood, such as Ang Lee's *Crouching Tiger Hidden Dragon* (2000) and Zhang Yimou's *Hero* (2002), but China's main effort was directed at replacing Hong Kong as the centre of film production for the Chinese diaspora. East Asia is now a big regional market with Korea finally overcoming its historic diffidence towards Japan and allowing Japanese films free access to its market (while also taking on much of the menial work involved in the making of popular Japanese 'anime' films for international consumption).

The case of Indian cinema is even more interesting. Since the 1950s Indian films have had a wide if largely unnoticed circulation, not only in places with a large Indian diaspora such

as Britain, East Africa, or the Caribbean, but also in much of Asia and even in the former Soviet Union. While the cinema audience in India itself remains enormous (numerically, though not in money terms, since ticket prices are very low), the efforts of Indian producers have come to be focused more and more on export markets, reached by cable and satellite as well as by theatrical exhibition and personal appearances by Bollywood stars such as Shah Rukh Khan in London and other Western cities. The export audience for Indian cinema is not only the ever-growing Indian diaspora (increasingly incorporated into the storylines of the films) but millions of people across the world who remain resistant to the lures of Hollywood and Western values in general. This is a huge culture zone which the modern West continues to ignore (to its peril), and which Indian cinema serves better than any other.

Meanwhile, in the West itself, 'Hollywood' has ceased to be purely American. One of the effects of the liberalization of capital markets has been to open up the American film and media industry to foreign investors. The Japanese company Sony acquired Columbia Pictures in 1989, Rupert Murdoch bought Fox, and for a while the French conglomerate Vivendi held a major stake in MCA–Universal's film and music business. These acquisitions did not have much effect on the sort of films that got made and distributed, since the foreign investors were principally interested in the money they could make out of their new investments, and if the public was thought to want American movies then that was what the foreign-owned companies would continue to produce. But Vivendi (originally a water company, one of whose subsidiaries holds the contract for waste disposal in the part of London where I live) did make a point of retaining control of the French part of its film operations, Studio Canal, when it pulled out of Universal—to the relief of film industries across Europe, since Studio Canal was and has remained a major co-producer and distributor of European films.

But while national borders diminished in importance, languages did not. An English-language soundtrack has become a *sine qua non* of most European films aiming for international distribution. Even the normally recalcitrant French were forced to toe the new line, with Luc Besson's spectacular *The Fifth Element* (1997, starring Bruce Willis) shot in English and dubbed back into French for the domestic market.

In the world of English-speaking cinema, a new fluidity reigns (see Figure 5). An American company, Miramax (now part of the Disney Corporation), entered the art cinema market with *faux*-French concoctions like *Chocolat* (2000), directed by a Swede and shot in English with Johnny Depp and Juliette Binoche in the starring roles. Closer to the mainstream, Warner Bros. invested both in the bizarre Australian dystopia that is the 'Mad Max' series (1979–2015) and in the quintessentially British 'Harry Potter' series, with shooting and post-production in British

5. Ryuichi Sakamoto and David Bowie in Nagisa Oshima's internationally co-produced *Merry Christmas, Mr. Lawrence* (1983).

studios. Going in the opposite direction, a British company, Working Title, has produced most of the films of the brothers Joel and Ethan Coen, from *Barton Fink* (1987) onwards—films that are as quintessentially American as Harry Potter is British. Within Europe, meanwhile, film-makers from smaller countries such as the Finn Aki Kaurismäki and the Hungarian Béla Tarr have often chosen to set their films elsewhere in Europe and with English (or occasionally French) soundtracks. (In Kaurismäki's case the compliment was returned when the American 'indy' film-maker Jim Jarmusch set an episode of his 1991 film *Night on Earth* in Helsinki, with dialogues in Finnish.) Nor is this transnationalization of cinema a purely Western phenomenon. The last film by the great Iranian film-maker Abbas Kiarostami, *Something Like Love* (2012), was made and set in Japan, in Japanese and with a Japanese cast.

While flows of money have changed the structure of the film industry, without necessarily having all that much effect on the content of films, the postcolonial flows of people that began in the 1950s have had little impact on the mainstream industry but had various disparate effects on cinema more widely. They have generated new film movements, such as *cinéma beur*—films made by and mainly for North African immigrants to France (*beur* is backslang for *Arabe*). They have created new types of audience—that for Indian films in Britain, for example. And the multinational and multicultural character of modern American and European cities has belatedly come to be recognized in films by white film-makers as well as film-makers of colour. If these disparate developments have anything in common it is that in one way or another they contribute to the transnationalization of cinema, challenging the fixity of borders between supposedly homogeneous nations. In the majority of cases they also provide a salutary reminder, if such be needed, of the importance to cinema of circuits of distribution and exhibition outside the monopolized mainstream.

In many respects, however, the world's film industries continue to follow the template set down nearly a century ago, in the 1920s. In revenue terms, the major Hollywood companies now hold 75 per cent of the world film market, which is about the same as they held (in a smaller world) in the 1920s, the difference being that these companies are no longer just film companies but conglomerates with a wide portfolio of investments, and no longer 100 per cent American. Meanwhile the remaining 25 per cent represents more cinema attendances and more viewings of films on the small screen than show up in the studios' balance sheets. Although there have been losers, mainly among European national cinemas, whose share of their own domestic market has dropped vertiginously in recent years, the overall world picture is one of immense variety—both in the nature of the films being produced and in the ways in which they circulate and can be viewed.

Chapter 4
Cinema as art form

In the years before World War I there were few people who
thought that cinema was or might become an art form. There was
no denying the artistry of certain people working in cinema—comics
such as Max Linder or the young Charlie Chaplin, actresses such
as Asta Nielsen or Lillian Gish, and even the occasional prestige
director such as D. W. Griffith. But the form as a whole had no
shape to it and there was very little sense of how it might develop.
It was also greatly hindered by its lack of official recognition.
In France it was classified as a second-rate form of entertainment,
on a par with the music hall but not the legitimate theatre.
In the United States the Supreme Court declared cinema to be
a 'business pure and simple' and so not protected by the First
Amendment to the Constitution guaranteeing it freedom of
speech. This liminal status was to persist until cinema had indeed
become an art form, with the Supreme Court only fully reversing
its position in 1951.

From about 1910, however, signs emerged that cinema was on
the road to acquiring some sort of legitimacy, if not in the eyes
of legislators. These signs initially pointed in quite different
directions, but eventually converged sufficiently for a cluster of
forms to develop which were to become cinema as we know
it today.

The first route took the form of an appeal to distinguished examples of existing forms. One-reel, simplified, reach-me-down versions of Shakespeare plays were produced in Britain, the USA, and Italy in the early silent period, sometimes showcasing in dumb-show the performances of famous actors such as Fyffe Robertson. Adaptations of respected plays (and occasionally novels) became the speciality of a French company known as Films d'art, which in 1912 persuaded the great actress Sarah Bernhardt to reprise for a feature film her role as the tragic heroine of Alexandre Dumas' *La Dame aux Camélias*. But the 'art' in the company's name was little more than a homage to the works being drawn on. The films it produced made only a minor contribution to the art of film as such, being very obviously staged performances presented frontally and with minimal recourse to the editing techniques that were beginning to be developed elsewhere, mainly in the USA. The acting was also fairly crude, and Bernhardt seems to have been an exception in applying herself seriously to producing performances calibrated to the potential of the new medium.

The idea that cinema could only progress by focusing on its difference from other art forms was first put forward by a French writer of Italian ancestry called Ricciotto Canudo in 1911. In an essay entitled 'The Birth of a Sixth Art', he boldly declared that cinema would be the first art to overthrow the canonical distinction put forward by the 18th-century German playwright and aesthetician Gotthold Ephraim Lessing in his *Laocoon* (1766) between poetry as the art of time and painting and sculpture as arts of space. Not so, said Canudo. Instead cinema, as 'the sixth art', 'will be a superb conciliation of the Rhythms of Space (the Plastic Arts) and the Rhythms of Time (Music and Poetry)' and had a promised future as 'a Painting and a Sculpture developing in time'.

Other writers followed in Canudo's footsteps, first in France and then in Russia, where film-makers began to develop theories of

montage, or the creative juxtaposition of disparate shots, as the guiding principle of film art. The first to do so was Lev Kuleshov, whose famous 'experiment' consisted of the same shot of the actor Ivan Mosjoukine placed successively next to shots of a bowl of soup, a dead woman in a coffin, and a child playing—interpreted by the audience as if the actor's expression had changed, although it hadn't.

More significant than Kuleshov was Sergei Mikhailovich Eisenstein, who put his own and Kuleshov's ideas into practice in films such as *The Battleship Potemkin* (1925) and *October* (1927, see Figure 6), and elaborated a comprehensive theory positing the concept of montage as dynamic principle behind not only film but art in general. Later, when the coming of sound seemed to have made montage cinema a thing of the past, Eisenstein even produced his own 'Laocoön' essay (1937), seeing montage in

6. The storming of the Winter Palace in Sergei Eisenstein's *October*, made in 1927 to celebrate the tenth anniversary of the Bolshevik Revolution.

the widest sense as an articulation of space and time, consummated in the cinema.

Equally important for the aesthetics of the new medium was the idea of *photogénie*, put forward by the film-maker Jean Epstein in 1924. Photogenic in English has become little more than a synonym for pretty, but for Epstein *photogénie* meant much more. He defined it as 'any aspect of things, beings, souls, whose spiritual character is enhanced by filmic reproduction'. By the time Epstein was writing, cinema was already advancing along the path of constructing images that enhanced the natural properties of the objects which provided it with its starting point, whether through direction, cinematography (especially lighting), editing, performance, or design. What Epstein added was a rationale which raised these activities above the level of mere prettification and saw in cinema a potential for the film image to do through the photograph what other arts did in more artificial ways.

The ideas of *photogénie*, montage, and the articulation of space and time were all the product of the modernist ferment of the 1910s and 1920s. At first they had little immediate resonance in the wider world, but as time went on they came to form the dominant theory, if not of what cinema was—because on the whole it wasn't—then of what it could aspire to be.

Editing and narrative

You can't run without first learning to walk, and by the time most of this theorization of cinema's potential took place the first practical steps had already been undertaken towards a distinctive identity for the new art form. The first step that had to be taken was to achieve a shift that has been variously described as from showing to telling or, in Tom Gunning's formulation, to move from being a 'cinema of attractions' to becoming a 'cinema of narrative integration'. This move was never absolute. The cinema has retained an ability to show as well as to tell (as it does in

documentary for example) and to hold loosely within itself elements which refuse total integration into narrative (as it does in spectacular genres as various as the musical and science fiction).

Most of the crucial steps towards developing a distinctive language of cinema were taken largely anonymously and by trial and error as film-makers set out to articulate simple narratives in a way comprehensible to the ordinary spectator. Before montage became a way of creating complex meaning, simple editing techniques had to develop which carried the spectator across space and time, establishing relations of sequentiality and with them cause and effect, with as a further refinement the linking of exterior and interior, action and character, objective and subjective. The great name associated with this latter development, as Eisenstein himself recognized, was the American David Wark Griffith, who can be credited with the first systematic use of the emotive close-up, often involving the terrified face of his favourite actress, Lillian Gish. The basic materials with which Griffith was working had been experimented with before but never to such effect or with such momentous consequences. Prior to Griffith, cinema had been mainly an action medium, with occasional forays into mimetic melodrama, most spectacularly in Italy. Afterwards, for good or ill, it became a vehicle for relating action to psychological motivation and changing emotional states.

The techniques developed in Hollywood from the early 1910s onwards for putting scenes together were to become systematized in a form known as 'continuity' or 'invisible' editing. The principal aim behind them was to make the narrative proceed in an apparently seamless manner, without the spectator being made too much aware of the shot transitions that brought in new information by which the story was carried forward. Until such time as a change of setting was required, the action needed to appear continuous, even if in real life it could not have been. The technique also became known as 'analytic' editing because it presupposed a careful breakdown of the action prior to shooting

to ensure that the action was fully self-contained and proceeded in apparent continuity, without the intrusion of extraneous elements that might distract from the main narrative purpose.

From Hollywood the new techniques spread rapidly to Europe and Japan and in due course came to provide the standard basic language of television as well. But although widespread they never became universal, even in America, where Griffith for example, notably in *The Birth of a Nation* (1915) and *Intolerance* (1916), went in for montage effects which were far from invisible. Meanwhile European film-makers, even when not going in for visible effects, were somewhat looser in their application of the 'rules' for film editing as practised in Hollywood. European directors who emigrated to the United States from the 1920s onwards were regularly impressed (and sometimes appalled) by the rigour with which these rules were imposed, while those who stayed behind enjoyed greater freedom to experiment with a more open-ended mode—either in the direction of assertive effects of deliberate discontinuity or, in the opposite direction, achieving continuity through long takes in which all the elements of a scene were contained within a single long-held shot. Both in the United States and elsewhere, however, the guiding principle behind even loosely applied continuity editing was the need to produce an illusion of reality that could last as long as the film was running, however implausible the events portrayed might seem in the cold light of day.

Genre

Analytic editing provided the building blocks of a language with which stories could be articulated. But what of the stories? From the earliest times films were organized into recognizable genres, mostly inherited from those that already existed in theatre and popular literature. Thus westerns and crime films were able to draw on an existing corpus of novels and stories, melodramas followed 19th-century theatrical models, and so on. Organization into

genres suited both the industry, which could produce genre films cheaply to a formula, and the audience, which enjoyed their predictability and their, on the whole, happy or uplifting endings.

One early genre that rapidly outgrew its music-hall origins was silent comedy. Instead of single comic turns performed as if on the music-hall stage, gags were brought out into the open and linked together in a narrative involving diverse characters but always centred on the adventures of the principal comic himself. Each comic had a distinct and immediately recognizable set of attributes and accoutrements: the implausibly dapper Max Linder; Charlie Chaplin, the 'little tramp', with his baggy trousers, walking stick, and bowler hat; Buster Keaton with his poker face and little boater hat always worn at a slight angle; Harold Lloyd with his owlish spectacles.

One of the many roles performed by silent comedy was to mimic and sometimes mock other cinematic genres, particularly melodramas. Although the most obvious forms of conventional melodrama, replete with clean-cut hero, scowling, mustachioed villain, and wide-eyed innocent heroine, had fallen out of favour by the end of the silent period, a generic mode that is sometimes described as melodramatic came to prevail in most popular cinemas, not only in Hollywood. Into this overall mode fall various forms of adventure and romance, usually with a happy, or failing that redemptive ending. But it is only in a very loose sense that the variety of narrative sources thrown into the melting pot of what became cinema can properly be described as melodrama. From very early on, all sorts of models were pressed into service to provide storytelling fodder for the new medium. These could be novelistic, dramatic, or based on traditional stories of an epic stamp, such as the Indian *Mahabharata*, *wuxia* tales in China (the source of countless martial arts films), and various forms of historical *jidaigeki* in Japan. Their compression into feature film format necessarily changed their character in various ways and to some extent homogenized them. But their reshaping as

film genres, fulfilling familiar expectations on the part of the audience, has still left room for a great variety of value systems and narrative outcomes.

The great American genres which became popular throughout most of the world included westerns, crime films of various sorts (usually seen from the point of view of the forces of law and order), and with the coming of sound the musical. Horror and science fiction were slower to coalesce into distinct genre formats, with Germany providing both the first Dracula film (F. W. Murnau's 1922 *Nosferatu*) and Fritz Lang's *Metropolis*. It was also easier in Europe for crime films to have the criminal as hero, as in the early serials of Louis Feuillade such as *Fantômas* (1913) and Marcel Carné and Jacques Prévert's *Le Jour se lève* (1939). Another genre which has remained popular was the historical epic, originating in Italy with, for example, Giovanni Pastrone's *Cabiria* (1914), before becoming indelibly marked as a Hollywood speciality through the work in particular of Cecil B. DeMille.

Almost universally, a pattern developed in which films were either out-and-out love stories or at least contained a 'love interest', regarded as essential if the film was to retain the attention of the female audience. (In the rare cases where a novel being adapted contained no female characters, a love interest might be concocted for the purpose, as with Alfred Hitchcock's 1935 version of John Buchan's *The 39 Steps*.) In male-oriented genres such as the western, the hero would often be charged with a task to perform, at the end of which, mission accomplished, he would also win the girl, though in detective films, as in the novels from which they were usually adapted, he might remain chaste throughout (or only engage in an insignificant fling), in order to return unencumbered in the next story in which the same character would appear. Rare indeed are films in which the gunfighter (or in Japanese films, the lone samurai) rides off alone into the sunset, though there are some notable exceptions, such as George Stevens's *Shane* (1952), John Ford's majestic *The Searchers* (1956), Akira Kurosawa's

Yojimbo (1961), and its more famous remake, Sergio Leone's *A Fistful of Dollars* (1964).

As for the heroine, if she has been a 'bad girl' or even worse a 'fallen woman', she will have to redeem herself in some way, as the former prostitute Dallas does in Ford's 1939 *Stagecoach*. More often she will have to die, as happens in Max Ophuls's masterly 1948 adaptation of Stefan Zweig's *Letter from an Unknown Woman* (and, more widely, in other adaptations of classic tales of adultery).

The presence of regularities of this kind—and they are mostly regularities rather than rules—is definitional of the genre film and helped the absorption of works of high as well as popular literature into recognizable popular formats. Films which were not assimilable in this way were rare in Hollywood before the 1970s, though more common in Europe. But the contours of genres were never rigidly fixed and have changed over time, in line with changes in social attitudes. This is particularly the case with gender roles. The classic pattern of active male and suffering female, replicated in many Hollywood 'women's pictures' in the 1930s and again in the 1950s, may have suited conditions in which women were confined to stifling domesticity (and even in this period there were plenty of exceptions both in real life and in the cinema), but it could not survive in a world where women were beginning to enjoy new forms of financial and sexual autonomy. Westerns changed too, with the belated recognition (as in Ford's 1964 *Cheyenne Autumn*) that the 'conquest of the West' was a genocide, and not just an onward march of civilization.

Not that genre films, even nominally realistic ones, should ever be taken as simple mirrors of real life. On the contrary, they were always to a greater or lesser extent—and this has always been their great strength as well as their greatest limitation—transfers to a different register of underlying situations and conflicts, with powerful resonances in the imaginary even more than in ordinary

reality. Thus the construction of an often fictitious enemy, whether in the form of aliens from outer space, vampires, or master criminals, could invoke deep-seated anxieties either to do with actuality (such as the Cold War in the 1950s) or of a more permanent kind rooted in the human psyche.

Sound cinema

The coming of synchronized sound around 1930 did not immediately change basic storytelling techniques, but it changed just about everything else. Most obviously, it added dialogue, which tended, at least in the early years of the expanded medium, to be quite theatrical. It altered the rhythm of films, making them faster because they were no longer encumbered by intertitles. With the need to match not only action but dialogue, editing became even more of a fine art.

Where synchronized sound did affect storytelling was by making it much easier to structure stories with a complex time frame. In the late 1930s and 1940s there was a vogue for telling stories mainly in flashback, with a series of scenes from the past being used to explain a present enigma posed at the outset of the film. Why in Orson Welles's *Citizen Kane* (1941) does the dying Kane whisper the word 'Rosebud', or why does Lisa's voice-over at the beginning of *Letter from an Unknown Woman* cryptically announce, 'By the time you get this letter I may be dead'? Usually in such stories the enigma is resolved, but in later films such as Alain Resnais' *Last Year in Marienbad* (1960) the dual time frame leaves matters in doubt as hero and heroine continue to disagree as to what did or did not happen in Marienbad the year before.

As well as dialogue, synchronized sound also brought with it the integration of music into the fabric of the film, either as background or, in the case of the musical, as the centrepiece of the film itself. No longer was music an addition to the film,

dependent on the resources available to theatre managers and the resident pianist or orchestra. Now every element of the score could be thought out and minutely cued in advance, and would be the same wherever the film was shown.

Musicals used popular show tunes for song-and-dance numbers, but the prevailing style in Hollywood for music as an accompaniment to the drama was derived from the 19th-century Romantic tradition and performed by the studio's in-house symphony orchestra. Distinctively 20th-century styles of classical music using smaller (and cheaper) ensembles appeared from time to time in European films and in documentary, while outside Europe film scores tended to mix elements from native and Western traditions.

Generally the purpose of film music was to add emotional colouring to the drama, but it could also be integrated into the narrative. Max Steiner's score for *Casablanca* (1942) provides a classic example, incorporating patriotic music (the 'Marseillaise') and a sentimental song ('As Time Goes By', associated with the Ingrid Bergman character) into its generally lush symphonic scoring.

Music for emotional colouring continued to dominate film music even after the symphonic score fell out of favour from the 1960s, to be replaced by a variety of modes, including the discreet use of modernist motifs on the one side and the incorporation of rock music on the other. Modern music tracks (they are not always scores in the traditional sense) are in fact extremely eclectic. Hardest to integrate into the fabric, though for different reasons, have been pre-Romantic classical music (too tightly structured in its own right) and modern jazz. There have, however, been films featuring the life and music of both classical and jazz musicians (e.g. Jean-Marie Straub and Danièle Huillet's 1968 *The Chronicle of Anna Magdalena Bach* and Clint Eastwood's 1988 biopic of Charlie Parker, *Bird*), and at least one case of a great modern jazz score, that by Miles

Davis for Louis Malle's 1958 thriller *Lift to the Scaffold* (US release title, *Elevator to the Gallows*).

With synchronized sound two kinds of cinema were lost, though not entirely. One was montage cinema on the Eisensteinian pattern, which could not be adapted to the needs of dialogue. Montage itself survived, but its use as a significant creator of meaning was restricted to documentary. Fiction films occasionally deployed montage effects (for example in *Citizen Kane*) to indicate the passage of time, but for the most part continuity editing prevailed and has continued to do so.

The other great loss was silent comedy. Chaplin continued to make films without dialogue throughout the 1930s (for example *Modern Times*, 1936) and some silent comedians such as the great duo of Stan Laurel and Oliver Hardy were able to integrate dialogue into their routines, but the other great comedians of the silent period fell by the wayside and the genre itself went into abeyance. In its place came on the one hand films which combined visual gags with witty or zany dialogue—the extravagant wordplay of Groucho Marx or the (often censored) sexual innuendos of Mae West—and on the other hand sophisticated comedy modelled on Broadway theatre and its equivalents elsewhere. The new genre reached its apogee in Hollywood around 1940, with films such as *His Girl Friday* (Howard Hawks, 1939), *The Philadelphia Story* (George Cukor, 1940), and *The Lady Eve* (Preston Sturges, 1941), but it had some fine exemplars in Italy (Mario Camerini's *Il signor Max*, 1937), in France (Sacha Guitry's *Le Roman d'un tricheur*, 1936), and in Britain (Anthony Asquith's 1938 adaptation of George Bernard Shaw's *Pygmalion*).

Sophisticated comedy, it turned out, had a better home in the new genre of the musical than in straightforward drama. (*Philadelphia Story* was to be remade in 1956 as the musical *High Society* with Grace Kelly and Frank Sinatra, and *Pygmalion* readapted as *My Fair Lady* in 1964.) Meanwhile audiences the world over

lamented the loss of more knockabout forms of comedy and lovable comic figures. This was particularly the case in Europe, where comics and comic actors such as Macario and Totò in Italy, Bourvil, Fernandel, and Louis de Funès in France, and George Formby and Norman Wisdom in Britain were hugely popular with audiences, particularly in the post-war period. Their films often topped the box office in their home countries but did not travel well. Not a single film by the sublime Totò was commercially released in Britain before Mario Monicelli's *I soliti ignoti* in 1958, in which he only plays a minor role. Only Jacques Tati, essentially a silent (or, more accurately, non-verbal) artist, broke through linguistic and cultural barriers, finding international success with *Monsieur Hulot's Holiday* in 1951 and *Mon oncle* in 1958.

Neo-realism and the new waves

At the end of World War II the cinema found itself at a crossroads. There was a strong desire for a return to the pleasures of peaceful pre-war life and the entertaining cinema of the 1930s. But there was also a call for change and for no return to the bad old days of Fascism, mass unemployment, or the war itself. This contrast played itself out in different ways. On the one hand the Hollywood musical (now in glorious Technicolor) enjoyed revived popularity, with a special unit headed by Arthur Freed at MGM producing films like *The Pirate* (Vincente Minnelli, 1948) and *On the Town* (Stanley Donen and Gene Kelly, 1949). But on the other hand, particularly in war-torn Europe, there was—in the words of scriptwriter and theorist Cesare Zavattini—a new 'hunger for reality' which found its most vigorous expression in the Italian neo-realist movement, of which Zavattini himself was a leading proponent.

Neo-realism was a revolt against the confectioned cinema of the 1930s—specifically that of Italian Fascism but also that of Hollywood and its epigones. It stressed simplicity of means, shooting where possible in real locations, with ordinary people

(often played by non-professional actors) as protagonists. Not many films that were labelled as neo-realist at the time fully lived up to the austere specification laid down by Zavattini, and those that did were rarely successful at the box office. Roberto Rossellini's *Rome Open City* (1945) was a huge success, but its realism was tempered by melodrama and it came out before American films had returned to the Italian market to provide it with competition. Vittorio De Sica and Zavattini's neo-realist masterpiece *Bicycle Thieves* (1948) was less successful at the box office, and later films by Rossellini (e.g. *Stromboli*, 1949) or by De Sica and Zavattini (*Umberto D*, 1952) even less so. By 1953, in fact, neo-realism as a movement was effectively dead in its country of origin.

By that time, however, neo-realist films had been widely seen in art-house cinemas in North America, Europe, and beyond, and a critical consensus had arisen that they provided a must-see alternative to conventional studio cinema. Many of the critics who admired them were to become film-makers in their turn and were to put into practice some or other feature of what they had found so admirable or exciting about them. Among the generation which came to the fore in the 1960s and owed and acknowledged a debt of some kind to neo-realism were Satyajit Ray in India, Nagisa Oshima in Japan, Glauber Rocha in Brazil, Júlio García Espinosa in Cuba, Shirley Clarke and (later) Martin Scorsese in the United States, Lindsay Anderson and Karel Reisz in Britain, and many film-makers in Eastern Europe eager to escape the straitjacket of official Socialist Realism.

Most of these film-makers had political as well as aesthetic reasons for following the neo-realist example, and many had come directly under the influence of Zavattini who, with less and less to do in Italy, travelled the globe to spread the neo-realist message. In France, however, the case was different. Here the main intellectual inspiration came from the critic André Bazin, and the motivation was principally aesthetic and, beyond that, ethical.

As early as 1945, in an essay entitled 'Ontology of the Photographic Image', Bazin had tentatively defined cinema as 'the realization [*achèvement*] in time of photographic objectivity', thus combining Canudo's vision of cinema as an art of both space and time with Epstein's concept of *photogénie*. In subsequent essays Bazin put flesh on the bones of this definition. Sharply distinguishing a cinema of reality from a cinema of the image, he praised films, such as those by Jean Renoir in France, Rossellini and De Sica in Italy, and William Wyler in Hollywood, in which space and time were minimally tampered with by editing and so retained their real-world properties, and where real (or real-seeming) people acted out their lives in real settings. Above all, however, he insisted on cinema's unique ability to let reality reveal itself without any attempt to force it into any preconceived notion of what it was.

Bazin's ideas have left a lasting legacy on thinking about the cinema, but more immediately significant was the influence he had on the young critics and aspirant film-makers clustered around him on the magazine *Cahiers du cinéma* in the 1950s—notably Éric Rohmer, François Truffaut, Claude Chabrol, Jean-Luc Godard, and Jacques Rivette—who were to form the nucleus of what was to become the French New Wave. Cheaply made and distinctive in tone, early New Wave films such as Truffaut's *Les Quatre Cents Coups* (1959) and Godard's *À bout de souffle* (1960) signalled the arrival of a new generation with a fresh approach to life and how to capture it on film, and were as important for the 1960s as neo-realism had been ten or fifteen years earlier.

Unlike the neo-realists, however, the New Wave film-makers were also passionate devotees of American cinema. They enthused both about run-of-the-mill Hollywood films, including B-pictures, with their functional *mise en scène* and generally understated acting, and about a select pantheon of great 'auteurs', led by Hitchcock and Howard Hawks, in whose work they saw individual artistic qualities which transcended the limits of the system within which they worked. This admiration for Hollywood cinema

shows up to a significant extent in their own films, with both Truffaut and Godard picking up motifs and tropes from American crime films, and Chabrol in particular finding inspiration in Hitchcock.

But their earlier critical writing in *Cahiers du cinéma* was of equal—if paradoxical—importance for the history of cinema. Writers like Robin Wood and V. F. Perkins in Britain, and Andrew Sarris in the USA, brought a new respect for the artistic richness of Hollywood films into critical discourse—just at a time when Hollywood itself was entering a phase of decline and desperately in need of the kind of renewal that was happening elsewhere in the world. Then, when Hollywood did begin to renew itself artistically in the late 1960s and early 1970s, with films like Arthur Penn's *Bonnie and Clyde* (1967) and Scorsese's *Mean Streets* (1973), it was often under the influence of the new cinemas springing up in Europe and beyond. The film-makers of the 'new' Hollywood, including commercial innovators such as George Lucas and Steven Spielberg, brought with them an altogether different and more eclectic film culture than that possessed by the generation they displaced. As an adolescent, Scorsese grew up watching Italian films of all kinds on a local TV channel, then went to film school at New York University where he came under the spell of the New Wave and of American independent film-makers such as John Cassavetes (*Shadows*, 1959); he then started his own film career working at Roger Corman's American International Pictures, which specialized in low-budget horror and other genre films. Other film school graduates followed suit, including Brian De Palma, whose youthful ambition had been to be the 'American Godard' but whose eventual career was as a maker mainly of horror films (e.g. *Carrie*, 1976), and more recently Kathryn Bigelow, who moved rapidly from avant-garde experiment (*The Set Up*, 1978) into various forms of genre film-making, including the science-fiction thriller (*Strange Days*, 1995) and that traditionally male-dominated genre the war film (*The Hurt Locker*, 2006).

The New Wave also brought with it a heightened consciousness of film as film and as personal expression. It came at a time when there was a growing public for films which were original not only in content, as neo-realism had been, but also in style—increasingly seen as the expression of artistic individuality. Recognized individual styles included the austerity of Robert Bresson in France, the refined minimalism of Yasujiro Ozu in Japan, and the eclectic but nevertheless distinctive techniques used by the Swede Ingmar Bergman to probe below the surface of dramatized emotion. To this mix the New Wave—particularly Truffaut and Godard but also Agnès Varda in *Cléo de 5 à 7* (1961)—added a new sense of modernity and openness, paving the way for the art cinema boom of the 1960s. With *L'avventura* in 1960, Michelangelo Antonioni shot from obscurity to become the emblem of a new kind of cinema which quietly subverted all the usual cinematic conventions about the relationship of character to action and the need for satisfying narrative closure. Federico Fellini, too, escaped the straitjacket of the hitherto dominant neo-realist aesthetic, first with his sprawling chronicle of contemporary Roman high-life, *La dolce vita*, in 1960, and then with the avowedly personal and subjective *8½* in 1963. The former surrealist Luis Buñuel, returning to Europe from a long exile in Mexico, came up with a series of non- or barely resolving narratives mixing reality and fantasy in unpredictable proportions, most notoriously in *Belle de Jour* (1967). Meanwhile in *Persona* (1966), Bergman offers no explanation of the heroine's apparent mental disorder nor of her possible partial recovery at the end.

All these films, however, remained on the whole self-contained fictions which, yes, had an author, but only as someone with a recognizable personal vision directing proceedings from outside. What the New Wave further added was a sense that film was, after all, only a fiction, which the author could interrupt at will—by briefly switching off the sound, as Godard does repeatedly from *Une femme est une femme* in 1961 onwards, or by having a character step out of their role to address the audience directly,

as the hero does in Truffaut's *Shoot the Pianist* (1960) when he covers up his girlfriend's exposed breasts, explaining to the audience that this is 'what they do in the cinema'.

'Baring the device' (and not merely body parts traditionally withheld from view) was to become a hallmark of many of the new cinemas of the 1960s. Initially used mainly for comic effect, the exposure of the mechanisms of cinema was to acquire a political as well as aesthetic purpose in Godard's work from *Two or Three Things I Know about Her* in 1966 onwards, as he began to dismantle not just the mechanics of cinema but its ideological underpinnings as well and its claims as a purveyor of truth.

Godard was not alone in his insistence that reality did not simply reveal itself through the cinema but needed to be interrogated. The new cinemas which sprang up across the globe in the 1960s—in Italy, Czechoslovakia, Yugoslavia, Cuba, Brazil, Japan, and elsewhere—all started from a broadly realist Zavattinian/Bazinian matrix and in varying degrees departed from it as the decade went on. The Czechs were on the whole the most conservative, and the minute observation of ordinary life remained a feature of the films of Miloš Forman and Ivan Passer, for example, right up to the destruction of the Czech New Wave that followed the Soviet invasion of their homeland in 1968. But in Yugoslavia with Dušan Makavejev and in Japan with Oshima, a more aggressively interrogative manner took hold, with sex (this being, after all, the 1960s) a particularly favoured subject of interrogation as well as display.

In Italy the most important innovator was Pier Paolo Pasolini. Already famous in the 1950s as a poet, novelist, and controversialist and (less famously but more lucratively) as an accomplished scriptwriter, Pasolini turned to film direction in the early 1960s, at first in a broadly realistic mode but soon developing in a more experimental direction. Defining cinema as 'the written language of reality', but one in which reality could be poetically transformed,

Pasolini was among the first of the new cinema film-makers to put himself forward in the first person in his own films. It could be pointed out that this was not an absolute novelty. Hitchcock and Welles often appear in their own films, and Charles Chaplin the director is sometimes barely distinguishable from Charlie Chaplin the little tramp. But the degree of self-consciousness at work in the first-person appearances by Godard and Pasolini was both more radical and more resonant in its effects.

By the early 1970s the new cinemas had lost their edge, aesthetically as well as politically. Their great achievement was to align cinema belatedly with the culture of artistic modernism. The cinema is intrinsically modern, but has rarely been modernist in the artistic sense. It grew up in the period of intense modernist ferment in the 1910s and 1920s, and during that period boasted a small modernist avant-garde, in France, Germany, and the Soviet Union. But this avant-garde more or less disappeared with the coming of sound in the 1930s, to revive only in very restricted artistic circles (mainly in New York and San Francisco) in the 1950s. Paradoxically it was the very novelty of cinema that kept wider currents of artistic modernism at bay until the 1960s. The modernism of Joyce in literature, Picasso in painting, or Stravinsky in music presupposed the existence of familiar traditional artistic and cultural forms to react against, and in cinema these had not yet taken hold. It was only after cinema had consolidated itself around a collection of basically 19th-century forms (from resolving narratives to lush symphonic music) that a reaction could take place that questioned these forms and took the cinema audience outside the frame of what cinema presented as the world.

The return of genre cinema

The new cinemas did not destroy the old, but they changed it. Most of the popular genres survived the upheaval of the 1960s, but they changed in character and the frontiers between them

became blurred. Musicals became fewer and so did westerns (reviving in the 1970s but only with their values radically subverted by the impact of the so-called 'spaghetti' westerns of Sergio Leone and others in the 1960s). Horror films continued to thrive, in Britain and Italy as well as in America, but their techniques for creating tension were increasingly imported into other genres. Take *Jaws*, for example. It is clearly a genre film, in the sense of using tropes common to most traditional film genres. But to which genre does it actually belong? Is it an adventure film, in many respects rather like a western? Or is it, like Spielberg's earlier *Duel*, basically a horror film, with the shark a quasi-supernatural enemy threatening not only the shark-hunters but the whole social order? Science fiction, too, is a genre which often invokes an enemy, but of a technological rather than supernatural kind, hybridized with the horror genre in films like those of John Carpenter (*Escape from New York*, 1981). Sub-genres developed, with violence against women, always latent in the horror genre, becoming explicit in the 'slasher' films which enjoyed a brief, unpleasant vogue in the 1980s.

The crime film genre (or genres) also underwent changes in the 1970s and beyond. Crime is such a universal subject of narrative fiction that it is not surprising that there should be film genres devoted to crime and its detection, or that crime should feature in many films which do not fit into any actual crime genre (Antonioni's 1950 *Chronicle of a Love Affair* and Bresson's *Pickpocket* from 1959 can serve as examples, but there are hundreds of others). Crime itself is a multifaceted and changing phenomenon, with films focusing on different aspects of it at different times, from gang warfare in the 1920s and 1930s to financial and cybercrime in the 2000s.

The most remarkable change undergone by the crime film from the 1960s onwards, however, concerns not content but form, and a single formal feature at that. In and around the 1940s there was a vogue for a style of film-making that has retrospectively acquired

the title 'film noir'. As James Naremore demonstrates in his book on the subject, this phenomenon is not susceptible of comprehensive definition, whether conceptual or historical. But one thing remained a constant for a long time. Alongside thematic elements such as femmes fatales and a generalized atmosphere of threatening corruption, a 'noir' film had to be in black and white. What killed the noir mode in the late 1950s was not a change in crime or criminals but the generalization of colour cinematography, first in Hollywood and then elsewhere. Just as musicals embraced colour as soon as possible, crime films resisted it until the last possible moment, and when they finally succumbed in the mid or late 1960s they were no longer noir. The reappearance of noir in the 21st century—in television crime series even more than in the cinema—is at least partly due to the belated success of cinematographers and engineers in creating a colour palette as eye-catching as the blacks, whites, and shaded greys of *Le Jour se lève* in 1939 or *Double Indemnity* in 1944.

Varieties of modern cinema

The panorama of modern cinema is very wide, though the full spectrum is not necessarily available in your local multiplex. At one end there are regular genre films that comprise the vast majority, whether rom-coms, science-fiction spectaculars, or, further afield, Bollywood song-and-dance extravaganzas. Then there are films which stay broadly within a genre format but play with it in various ways: the films of the Coen Brothers (perhaps most notably *The Big Lebowski*, 1998) all tend to do this. Then there are films which do not belong in any film genre but work on the whole within long-established conventions common to most forms of narrative or dramatic art. There are also films which hark back to the new cinemas of the 1960s: the work of the American independent film-maker Richard Linklater, especially his trilogy *Before Sunrise* (1995), *Before Sunset* (2004), and *Before Midnight* (2013), falls into this loose category, as do many other modestly budgeted films from Europe and beyond.

Finally, at the further extreme, there are the rebels, film-makers who have attempted, with varying degrees of coherence, to push the boundaries of cinema either outwards into uncharted territories or backwards, towards a new encounter with its lost destiny as a record of life being lived and as an art of space and time.

In 1995 a small group of Danish film-makers led by Thomas Vinterberg and Lars von Trier issued the 'Dogme manifesto', denouncing the cheap illusions fabricated by modern genre films and calling for a cinema which abjured any form of trick work and where the audience always knew exactly what they were getting and that what they were getting was a film, with the camera hand held and actor/characters explicitly seen to be performing in front of it. The Dogme group did not stay loyal to their own dogma for very long, with von Trier in particular finding that the objective he was seeking—the exposure of human truth in extreme situations (as in *Melancholia*, 2011)—was not best served by strict adherence to the rules he had helped to formulate. Dogme caused shockwaves at the time, but they were more the shockwaves of occasionally shocking content than anything like a seismic shift in the aesthetics of film.

Dogme 1995 was highly focused, basically limited to one country, and didn't last long. By contrast the tendency that has come to be known as 'slow cinema' (see Figure 7) is extremely diffuse, geographically widespread, and has been slow to gestate. Artists associated with this tendency (it is less than a movement) include, among others, Apichatpong Weerasethakul in Thailand, Béla Tarr in Hungary, Chantal Akerman in Belgium and France, and James Benning in the United States, and if they have a single shared objective it is to restore to cinema a sense of time as more than just a vector for action and plot but as the very substance of which cinema is, or can be, made. The passing of time, rather than mere slowness, is what slow cinema is mainly about, though obviously their films are much slower than regular films, in which time is almost always compressed.

7. **Slow magical realism: Apichatpong Weerasethakul's *Uncle Boonmee Who Can Recall His Past Lives* (2010).**

From the historian's point of view, however, the interest of slow cinema lies not so much in the films it has produced—some of which invite a form of disengaged spectatorship perhaps more suited to viewing at home or in the open spaces of an art gallery than in theatrical conditions—than in what it has to say about the evolution of cinema over the past half century and more. The lineage of slow cinema is rich and various. Acknowledged and unacknowledged influences on what slow cinema is doing today can be found in all sorts of places in the history of cinema—in theorists such as Bazin and Siegfried Kracauer, and in film-makers as diverse as Robert Flaherty and Carl Theodor Dreyer in the 1920s, Yasujiro Ozu from the 1930s to the 1950s, Michelangelo Antonioni, Agnès Varda, Jean-Marie Straub and Danièle Huillet, and Jacques Rivette from the 1960s onwards, and, coming from a totally different direction, Andy Warhol and other exponents of the post-war American avant-garde. These lineages are complex

and not easy to disentangle. If Wim Wenders's films from the 1970s are sometimes cited as an influence on slow cinema then one must also acknowledge the influence on Wenders himself of Ozu and Antonioni. Collectively, however, all point to the fact that the cinema has not always been straightforwardly in thrall to the demands of drama or narrative action. Films in which nothing much happens, or where what happens is only minimally dramatized, or where such action as does happen is interspersed with moments of stasis in which nothing 'happens' but time continues to pass, have always existed, even if pushed to the sidelines by films which engage the spectator in more obviously exciting ways.

Slow cinema offers the spectator an opportunity to think—whether about the world or about the way that world is represented in this and other forms of cinema. It will never replace those other forms, but its very existence is proof of how various those forms can be and what they will always have to offer.

Chapter 5
Cinema and the outer world

The world in which cinema grew up was one of constant change—not always for the better. There was technological change, of which cinema itself was part. There were wars and revolutions, leading to changes in the world order. Empires rose and fell. There was social and demographic change as more and more people across the world entered into the orbit of global capitalism or, more loosely, 'modernity'.

Cinema recorded and reflected these changes, but it also changed or was forced to change in response to them. At one extreme, what caused cinema to change could be something quite external, as with wars and revolutions. At the other extreme, changes took place as part of the internal dynamic of cinema itself, with no obvious stimulus from outside.

Not only did the world shape the cinema, or what cinema was to become, but cinema also played a major role in shaping the world, or at least what we imagine the world to be. At first the cinema simply recorded things in the world, then it became a means of representing them, and then from representing them proceeded to reconfiguring them, thereby providing contrasting views of how the world might be viewed and acted on.

Censorship and the public sphere

The rapid spread of cinema caught the world unprepared. From very early on, there was a widespread feeling that, while cinema might be entertaining and might even be informative, it was also dangerous. By 1905 or thereabouts, anxiety began to be expressed about what was being shown in the nickelodeons and other movie theatres springing up in the United States and elsewhere. At first it was the circumstances under which films were shown that were the object of concern. The licensing of film shows was a matter for local authorities. A major issue was safety, and fire risk in particular. But authorities were also concerned about disorder and unseemly conduct in the dark, crowded places where films were projected, and then, increasingly, the content of the films being shown. There was at first no formal censorship applied to the films themselves, only to their showing on particular occasions—as there might be to a strip show or a saucy vaudeville routine. The first calls for the pre-vetting of actual films came from exhibitors, who faced unpredictable risks of prosecution if a film they had bought sight unseen fell foul of local susceptibilities. In both the USA and Britain the industry set up semi-official censor boards in the early 1910s, hoping thereby to assuage public concern and ensure that a film, once released, would get safe passage wherever it was exhibited.

With the outbreak of war in 1914 a number of European countries followed suit, bur this time the initiative came from governments concerned to protect public morale as well as morality.

After the war, some form of state censorship became the norm in most European countries, but Britain and the USA persisted with attempts to self-regulate their industries and keep government interference at bay. In Britain, the British Board of Film Censors received official recognition in 1912 as an arms-length body (a status it has retained to this day, but with the word 'Censors' changed to 'Classification' in 1984 and a wider remit to include

video as well as film). In the USA, the wholly non-statutory National Board set up before the war proved ineffective as a putative censor and was soon sidelined, leaving a gap which took some time to fill.

In the immediate post-war years, Hollywood (as it had become) was rocked by a series of scandals, with the morals both of films such as Cecil B. DeMille's *Why Change Your Wife?* (1920) and the private (but highly publicized) lives of the stars becoming the object of hostile press comment and concerted campaigns by religious organizations. Faced with this threat to its profits as much as to its reputation, in 1922 the industry prevailed on the Republican politician Will Hays to take on the role of president of its newly formed trade organization, the Motion Picture Producers and Distributors Association (MPPDA—later renamed the Motion Picture Association of America, or MPAA). The result, several years down the line, was to be the Production Code, or Hays Code as it was popularly called (Figure 8).

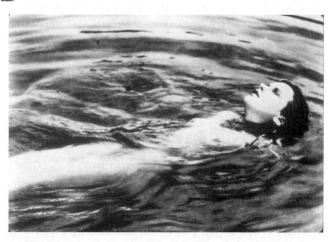

8. Permissible in Europe but not in the USA: Hedy Kiesler (Hedy Lamarr) in a scene from Gustav Machatý's *Extase* (1933). After moving to America, the actress tried and failed to have the picture suppressed.

The Code is mainly famous for its extreme prudishness and its creation of a world in which, as Linda Williams puts it, couples 'argued without swearing and had babies without copulating'. In fact the apparent prudishness was a front, put up to protect the innocent, and the Code was designed in such a way that more worldly wise audiences would always be able to see through it—to know, for example, that the saloon in *Stagecoach* was also a brothel, and that the bookseller in *The Big Sleep* (1946) was a trader in pornography and probably a homosexual (officially a taboo subject) to boot. The industry could therefore both have its cake and eat it, in pursuit of a strategy of always maximizing the potential audience and avoiding the need for any form of age restriction for 'adult' material such as was beginning to be introduced in Britain and Europe.

The primary purpose of the Code was always economic. While declaring itself to be an act of voluntary self-regulation in the (conservative) public interest, the Code was in fact, in the phrase of Richard Maltby, a form of 'market censorship', deploying elaborate mechanisms to ensure that no films would get made which would attract the attention of censors other than the Production Code Administration (PCA) itself.

After various false starts and prolonged negotiations, a first version of the Code was formulated in 1930 with a definitive version coming into force in 1934. Synchronized sound had made it much harder just to snip out bits of films to suit the demands of local censors, and it became imperative for the industry to be able to put out a film in a form which would pass unimpeded everywhere, both at home and abroad. Reluctantly, film-makers fell into line, but not without repeated attempts to smuggle in material they hoped would escape the notice of the Code's administrators.

In continental Europe and Japan the situation was different. Censorship was state-administered and often explicitly political,

particularly in countries with authoritarian or totalitarian regimes, which followed the American pattern of pre-censoring films at the script stage with the result that relatively little censorship had to be applied to completed films. In more pluralist countries, such as Sweden, France, and (after 1945) Italy, film-makers had much more scope to make and attempt to release films which risked not getting a certificate or being prosecuted for obscenity, blasphemy, or even, in some cases, offences against national honour. Sweden was on the whole relatively liberal about sex, but quite censorious about violence. In the post-war period in Italy there were quite a few politically motivated prosecutions of films by known left-wing film-makers, with Pasolini (a self-confessed small-c communist, atheist, and homosexual) a prime target of reactionary zeal. In France the Algerian War was a particularly touchy subject—Godard's *Le Petit Soldat* was banned in 1961, when the war was drawing to a close, and as late as 1966, when the war had been over for four years, Gillo Pontecorvo's Italian-Algerian co-production *The Battle of Algiers* was refused a certificate by the French authorities and remained unreleased there for five years.

In the late 1960s the whole elaborate edifice of censorship began to fall apart. Throughout the Western world public opinion had shifted decisively in favour of more openness, particularly in matters of sex. In the USA the PCA's writ only extended to films made or distributed by the MPAA's member companies, and independent distributors were free to take a chance on risky foreign films, which were beginning to acquire a foothold in the home market. (It was thanks to this loophole that Rossellini's *The Miracle* got released, leading to the Supreme Court decision in 1951 giving films the protection of the First Amendment.) In 1966, the new head of the MPAA, Jack Valenti, tore up the rule book, replacing the PCA with a less authoritarian system by which companies would be able to apply for an age-based rating with categories such as PG (parental guidance recommended) or R (restricted), enabling adults and older teenagers to see films which

would not have got through the now obsolete Production Code. This brought American practice into line with what was already the rule in many European countries and, although different countries continued to disagree as to exactly what was suitable for whom, some variant of the new system became the international norm and in the 1980s was extended to home video.

Not that censorship was entirely abolished. Governments and local authorities retained powers to overrule the decisions of ratings boards, though they used them less and less. Political censorship disappeared almost entirely in Western countries in the mid-1970s (though it remains powerful in China and India), leaving sex and violence (and in particular the combination of the two) the only major subject of contention. Two films in the 1970s, however, tested the tolerance of the authorities to the utmost. These were Pasolini's last completed film, *Salò, or the 120 Days of Sodom* in 1975, and Nagisa Oshima's *Empire of the Senses* the following year. Neither film was pornographic in the usual sense of the word, but both were highly sexually explicit and were banned in several countries for many years and only released uncut in Britain and the USA twenty or more years later.

Politics, revolutions, and wars

The Hollywood cinema in its 'classical' period—up to 1960 or thereabouts—was rarely overtly political. But it was always, and has remained, deeply ideological, projecting a set of consensual values, filtered through the Production Code. Throughout the 1930s it avoided engagement with world affairs, if only out of fear of losing foreign markets. The United States itself was represented as pluralist, full of people who had immigrated from somewhere but having immigrated were now all equally American and living in a peaceful and socially mobile democracy superior to the place (often unspecified) that they or their parents or grandparents had originally come from. The social order was basically just (Chaplin was out on his own in suggesting it wasn't) and if there was a

system the ordinary man could beat it, as for example in Frank Capra's *Mr. Deeds Goes to Town* (1936). The ordinary girl had her chances too, if only by marrying a millionaire. This idyllic vision was enormously consoling to the American spectator and equally appealing to the public in countries where the social order was more manifestly unjust.

Things changed—though not radically—with America's entry into World War II. Directors like John Ford and John Houston were enlisted into the armed forces and got first-hand experience of what war was like, and the State Department and Department of Defense became involved in guiding the course the cinema had to take in war conditions. After the war the Department of Commerce also began to play a major role in helping Hollywood regain lost markets. The Cold War had an influence too. Not only did it lead to the making of films in which Communists were the stereotyped villains, but the studios willingly co-operated with the House Un-American Affairs Committee in order to rid themselves of troublesome leftists in their ranks. This was a shameful episode which made a mockery of the industry's claims to neutrality and independence from government. Once the immediate post-war panic was over, however, Hollywood reverted to a position of being political only by default. Old wars were a safer subject than current ones.

There was one great anti-war film in the 1950s, Stanley Kubrick's 1957 *Paths of Glory*, and the Indo-Chinese conflict figures in Joseph Mankiewicz's 1958 adaptation of Graham Greene's *The Quiet American*, but throughout the late 1960s and early 1970s Hollywood steered clear of anything to do with Vietnam—either the war itself or the mounting protest against it. It was equally evasive about race relations, offering up sympathetic but unthreatening images of African Americans as in Stanley Kramer's *Guess Who's Coming to Dinner* (1967, starring Sidney Poitier) as a sop to middle-class black spectators. This was, of course, a great advance on the hideous racism of Griffith's

The Birth of a Nation in 1915 and the casual stereotyping of black people throughout the inter-war period, but even at the time it seemed curiously out of touch with the real conflicts affecting American society.

The situation was very different in countries caught up in the throes of violent conflict than in those such as the USA which remained largely untouched by either their process or their outcome. In consequence the history of the American cinema—the world's largest—followed a less tormented course than that of countries where the convulsions were more powerful, and this is reflected in the way their history has been told. Although the American cinema rose to pre-eminence partly as a result of World War I, its subsequent development was far more determined by slow-moving social and demographic changes within the USA itself than by catastrophic events taking place for the most part many thousands of miles away. The extra-cinematic factors that shaped the Hollywood cinema after 1918 were things like Prohibition, the moral panics surrounding supposed misconduct in Hollywood itself, social and racial tensions, or changes in the position of women or in sexual mores.

By contrast, no history of Russian cinema can be told without taking into account the central role of the 1917 revolution and the reversal of its effects around 1990. Nor can a history of any European or Asian cinema avoid the complex of events around World War II, from pre-war fascism to the war itself and subsequent decolonization and the Cold War.

After the revolution in 1917 the leading lights of the pre-war Russian cinema emigrated en masse, mainly to France. Their place was taken by members of the modernist avant-garde, including Sergei Eisenstein, Vsevolod Pudovkin, Ilya Trauberg, and the pioneer documentarist Dziga Vertov, who together created an entirely new cinema. This new revolutionary cinema did not last long, falling victim to Stalinist repression from about 1930

onwards. But even after its demise it remained powerfully inspirational in political and artistic circles in the West. Eisenstein was (and still is) the totemic name, but when 1968 happened it was the almost forgotten Vertov who had a sudden moment of glory when Jean-Luc Godard dissolved himself into a collective known as 'Groupe Dziga Vertov'.

World War I took place mainly in Europe and to some extent in the Middle East. World War II, however, was a truly worldwide event, which had its origins in Asia with the Japanese invasion of Manchuria in 1931 and finally ended only in 1949—in Asia with Communist victory in China and in Europe with the defeat of the Communist partisans in Greece. Not surprisingly, the effects of all these momentous events on world cinema, direct and indirect, were immeasurable and had many ramifications, by no means always predictable.

In Europe, the prelude to the war to come was the Nazi takeover of Germany in January 1933. Within months the biggest German film studio, Ufa, sacked all its Jewish personnel, forcing many of them into hiding or exile. Under the control of Joseph Goebbels, and deprived of many of its greatest talents, the once great German cinema sank into propagandistic mediocrity. Meanwhile Jews and other suspect individuals fled westwards, either direct to America or with staging posts in France. Hollywood was the major beneficiary of this mass exodus. By 1941, with two-thirds of Europe under German occupation, most of the great names of European cinema were in exile in California. The list included Fritz Lang, Otto Preminger, Douglas Sirk, Robert and Carl Siodmak, Edgar G. Ulmer, Billy Wilder, Max Ophuls, René Clair, Jean Renoir, Julien Duvivier. The French contingent, including the Franco-German Ophuls, all returned to Europe shortly after the war, but those of German and Austrian origin were reluctant to go back to countries which had treated them so badly and stayed in America, to the enrichment of the cinema in their adopted homeland.

While Hollywood gained creative talent, it also lost markets. The process began in 1938 with a small trade war (a skirmish, really) between the Fascist film industry in Italy and the Hollywood studios, who reacted to the Italians' threats by withdrawing their films from the Italian market. Then when the actual war got going, all trade in films between the United States and occupied Europe was suspended. For over five years no new American films were to be seen in any part of Europe other than Britain, Sweden, Portugal, and Spain. When trade was resumed in 1946, a deluge of American films, including for example *Citizen Kane* (1941) and *Casablanca* (1942), along with several hundred newer films, poured into Europe, providing irresistible competition for European film industries struggling to recover from wartime devastation.

One immediate effect of the war on cinema was a revival of the war film, which had been a very minor genre in the inter-war period although it did include two great films, Lewis Milestone's 1930 adaptation of Erich Maria Remarque's novel *All Quiet on the Western Front*, and Jean Renoir's prison-camp drama *La Grande Illusion* (1937). During the war itself the main combatant countries, the United States, the Soviet Union, Germany, Japan, Britain, and Italy, churned out a large number of films foregrounding the war, whether on the home front or on the battlefield. Many of the American examples of the genre were very artificial, more like westerns in disguise than proper war films, but they became increasingly realistic after 1943 when the USA became involved in actual land combat, as in the case of William Wellman's *The Story of G. I. Joe* (1944).

War films of various types remained popular after the war itself was over, at least in countries which had a self-glorifying story to tell—or were allowed to tell it. In Japan, the occupying Americans forbade the production of any films about Japanese military exploits of any period, not just contemporary ones, even going so far as to impose a ban on traditional *jidaigeki* or historical films

featuring heroic samurai. Needless to say, it was the victorious Allies—Britain, the United States, and the Soviet Union—that produced most of the post-war crop of war films, generally celebratory in tone though in the Russian case focusing as much on the sufferings of the people during German occupation as on derring-do on the battlefield.

Other occupied countries found stories to tell about home-grown resistance to the occupiers, starting with Italian neo-realism and Rossellini's *Rome Open City* (1945) and *Paisà* (1946). Many of these films, whether from France and Italy in the West or Poland and Yugoslavia in the East, were straightforward celebrations of a people supposedly united in resistance to the occupier. Uncomfortable truths about collaboration or internecine feuds within the resistance were glossed over and, apart from the occasional outlier such as Andrzej Wajda's *Ashes and Diamonds* (1959), it is not until around 1970, with films like Bernardo Bertolucci's *The Spider's Stratagem* (1971) and Marcel Ophuls's riveting documentary, *The Sorrow and the Pity* (1970), that the myths of the resistance began to be seriously challenged in the cinema.

The most important single effect of World War II, however, was the creation of a 'Soviet bloc', including China as well as most of the eastern half of Europe. This not only deprived America of markets, but it led to different cinemas developing on the two sides of what Winston Churchill described in a famous speech in 1947 as an 'Iron Curtain' descending across Europe. In China, as had been the case in Russia thirty years earlier, many film-makers emigrated. They settled in Hong Kong, which consolidated its position as the major supplier of films to the millions of overseas Chinese in South East Asia and elsewhere. Throughout the Communist world, cinema came under bureaucratic control, with a doctrine known as Socialist Realism imported from the Soviet Union and imposed as a political and aesthetic orthodoxy. The cinema was asked to do the impossible: to come up with films that

were, as Peter Kenez puts it, simultaneously 'artistically worthwhile, commercially successful, and politically correct'—and, one might add, 'realist' to boot.

Socialist Realism had been imposed as a doctrine in the Soviet Union in the early 1930s and took many years to dislodge, even after the rigours of Stalinism began to be relaxed from the late 1950s onwards. In Eastern Europe, however, its reign was mercifully short. Bureaucratic control only took hold in the late 1940s and was in many cases quite reluctant. From 1956 onwards a slow, if uneven, process of liberalization took place in most countries, starting in Poland and spreading to Yugoslavia, Hungary, and Czechoslovakia. By the mid-1960s films started appearing which were artistically original and often overtly critical of the political regime. Censorship remained both powerful and arbitrary and some films might be allowed for export but banned at home. The lightly satirical comedies of Miloš Forman in Czechoslovakia, the questioning historical epics of Miklós Jancsó in Hungary, and the savage indictments of Stalinist puritanism in the work of the Yugoslav Dušan Makavejev were to become an integral part of the dynamic new cinemas of the 1960s kick-started by the French New Wave. Revolutionary Cuba, too, developed a new cinema, taking its cue from developments in Western Europe rather than the Soviet bloc. Cesare Zavattini and the veteran Dutch documentarist Joris Ivens were invited to Havana to give advice, to be followed by Chris Marker, Agnès Varda, and others.

The year 1968 was pivotal for both the old and the new cinemas. In the East, the Soviet invasion of Czechoslovakia brought an end to the Prague Spring and cast the cinema of the Czech part of the country (though not Slovakia) back into the Dark Ages. Meanwhile, Western Europe and Japan were experiencing their own revolutionary ferment which briefly threatened to overthrow much of the capitalist order, cinema included. In the event, the direct effect of the convulsions of 1968 on cinema was slight, but when things settled down it became clear that the cultural

changes fermenting in the 1960s were there to stay. The cinemas that took shape on either side of 1968 were less consensual, and less inclined passively to accept commonplaces about the rightness of the values which cinema had clung on to even as the world changed all around it. As well as turning a critical eye on the present, as with the films of the prolific Rainer Werner Fassbinder, German cinema belatedly began the painful process of coming to terms with the recent past, for example in Hans Jürgen Syberberg's *Hitler: A Film from Germany* (1977) and Edgar Reitz's monumental *Heimat* (1980–4).

In the USA the western fell out of favour as a celebration of simple pioneer values. With the collapse of the Production Code, the domestic melodrama became less constrained by an obligation to support the pieties surrounding the sanctity of heterosexual monogamy. The handful of black characters (and actors) the system found room for no longer had to bear the burden of countering racism by being represented as paragons of virtue. Films looked different too, with a number of film-makers taking advantage of technological developments to shoot more on location, thereby producing films that at least ostensibly gave audiences a chance to see life as it really is, rather than a concoction prepared in a Hollywood studio. This was less than a revolution, and much of the mainstream cinema in both Europe and the USA remained as before, but it paved the way for the emergence of new black film-makers such as Spike Lee (*She's Gotta Have It*, 1986, *Do the Right Thing*, 1989) and for the New Queer Cinema of the 1990s exemplified by Gus Van Sant's *My Own Private Idaho* (1991).

Documentary and cinema as record

The basic fact underlying the reciprocal influence of the world on cinema and, more gradually, cinema on the surrounding world, was the new medium's unique capacity as a recording instrument. From the outset cinema showed things happening, or that had just

happened, whether simple things like a boxing match or a train arriving in a station, or more dramatic events like battles. The first known example of a battle presented on film was not a record of the event itself but a staged reconstruction of a cavalry charge in the Spanish–American War of 1898, but by the time of the Boer War a year or two later on-the-spot records were being made of events on the front line. Inevitably this had political consequences, with the authorities eager to ensure that the 'right' message was being put across by the images the film-makers had collected.

Film as record could take many forms. Before cinema even existed, time-lapse photography was used in 1878 by the pioneering photographer Eadweard Muybridge to demonstrate the actual movement of a galloping horse, which proved to contradict what generations of painters had imagined it to be. The moving image soon came to be used for creating and disseminating images of things the mechanical eye of the camera could see better than the human eye, and could bring out into the open and to more places. Alongside its spread as entertainment, the new medium of cinema quickly acquired an educational role, in developed and undeveloped countries alike. When Lenin famously declared in 1919 that 'for us the cinema is the most important of all the arts', what he had in mind was not in the first instance cinema as art but as an instrument of education and propaganda among the largely illiterate masses of the newly formed Soviet Union.

Meanwhile, in Western Europe and the USA the development of film as record was taking a different course. In 1909, as the industry began to consolidate, the French company Pathé replaced the random production of items of vaguely newsworthy interest with a whole new genre, the weekly or bi-weekly newsreel or Ciné-Journal. Other companies followed suit, and regular screening of newsreels soon became standard fare in cinemas throughout the developed world, being superseded by television in the 1950s and 1960s.

Pathé's example was followed in the Soviet Union, where weekly newsreels began to appear from 1918 onwards. Among the production team was the young Dziga Vertov, who went on to put his original ideas into practice in a series of films under the heading 'Kino-Glas' ('cinema eye') or 'Kino-Pravda' ('cinema truth') but later progressed to full-scale features, most famously *The Man with a Movie Camera* (1929), portraying the life of a city over twenty-four hours. By this time, however, a new genre had come into being, under the name documentary, whose most notable protagonists were the American Robert Flaherty and the Scot John Grierson.

In sharp contrast to Vertov, Flaherty was interested not in modernity and a world coming into being but in worlds that were disappearing, such as those of the Inuit (*Nanook of the North*, 1922) and the islands of the South Pacific (*Moana*, 1926). He was also not above embellishing and fictionalizing his 'documentary' material, cajoling the hunter who played the eponymous Nanook into re-enacting a form of seal hunt that his tribe had long since abandoned. In spite, or more likely because of this romantic fictionalization, *Nanook* in particular was enormously popular with audiences, running for several months in a Paris cinema on first release and being regularly revived thereafter.

Grierson was different again. Although he directed a couple of films of his own, notably *Drifters* (1929—premiered at the Film Society in London alongside Eisenstein's *The Battleship Potemkin*), his role in what came to be called the British documentary movement was more as organizer and theorist. In the early 1930s he came up with a definition of documentary as 'the creative treatment of actuality', which has given endless trouble to interpreters ever since. Did he mean documentary in general, or just the practice of the British movement? By actuality did he mean current events (in French *les actualités*, which also means newsreels), or Hegel's *Wirklichkeit*, meaning phenomenal

reality itself (Grierson had studied philosophy at the University of Glasgow)? As for creative, it was equally unclear how creative one could be with actuality without it ceasing to have documentary value. Neither at the time or since did anyone, least of all Grierson himself, come up with a satisfactory answer to these conundrums. But the phrase has stuck and the ambiguities it presents have become increasingly glaring as the use of the term documentary has spread to encompass all sorts of non-fiction forms in cinema and on TV.

By the time Grierson was writing, these non-fiction forms—whether under the name documentary or not—had long gone beyond their original function of recording things in the world, and reached a degree of complexity and variety parallel to that of their fictional counterparts. However much the unreflecting viewer might like to imagine things otherwise, the world does not magically rematerialize itself on the cinema or TV screen without the intervention of complex intentional processes. Throughout its history, documentary practice has been guided, Michael Renov suggests, by at least one of 'four fundamental tendencies or rhetorical/aesthetic functions', which he enumerates as follows: '1, to record, reveal, or preserve; 2, to persuade or promote; 3, to analyse or interrogate; and 4, to express.'

The work of the British documentary film-maker Humphrey Jennings can serve as an example of all four tendencies and functions at work simultaneously. Always an outlier in the documentary 'movement', Jennings used the observational long take to record aspects of working-class life in Britain in *Spare Time* (1939), before progressing to associative montage effects in *Listen to Britain* (1942, Figure 9) to promote a sense of national unity under wartime conditions, while at the same time trying to interrogate aspects of British and European culture and express his own sense of what this might mean in relation to both the present and the past, and then (in *Letter to Timothy*, 1946) a hypothetical post-war future.

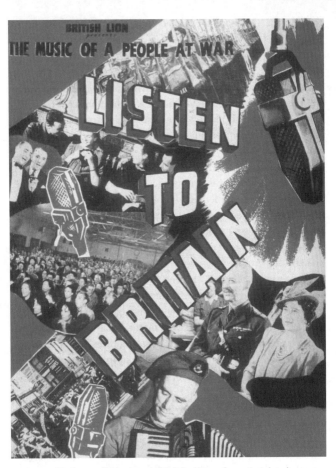

9. Poster (in form of photo-montage) for Humphrey Jennings's documentary *Listen to Britain* (1942).

Documentary was never really a popular form, but together with the weekly newsreel it came into its own briefly during World War II when governments had messages to put across, and audiences, at least in Britain and the USA, were eager for information about the war effort. It then went into abeyance in the post-war period.

The function of the newsreel was increasingly taken over by television news, while documentary proper became a form on which aspirant film-makers (e.g. Karel Reisz and Lindsay Anderson in Britain) could cut their teeth or the province of a handful of specialist film-makers such as the 'Flying Dutchman' Joris Ivens, who toured the world to produce front-line reports of anti-colonial struggles (and later the Vietnam war).

Then, around 1960, the world of documentary and newsgathering was revolutionized by the arrival on the scene of new, lightweight cameras and sound recorders, giving rise to the phenomenon generally (and misleadingly) known as cinéma vérité. This now popular and much abused term (an echo of Vertov's 'Kino-Pravda' or 'cinema truth') was coined by the French writer Edgar Morin to describe a film he and the ethnographic film-maker Jean Rouch were making (*Chronicle of a Summer*, 1960), in which a group of people would be filmed going about their lives and being interrogated by the film-makers about the truthfulness or otherwise of their self-portrayal on film. But it soon became adopted to refer to a parallel development in Canada and the United States in which ongoing events were captured without reflexivity by film-makers taking advantage of the unobtrusive new equipment to pass unnoticed among their subjects. Within a few years the new techniques became absorbed into regular documentary and newsgathering practice.

But to what extent did they deliver the truth promised in the term cinéma vérité? They certainly delivered immediacy and the kind of spontaneity that come with unrehearsed performance. They also meant less recourse would be needed to intrusive and often misleading commentary. (How misleading commentary can be had been pointed up in the French documentarist and film-essayist Chris Marker's *Letter from Siberia* in 1957, where the same set of images is shown three times, accompanied first by an approving commentary, then by a hostile one, and then by one that aspired

to neutrality.) Questions began to be raised about both the truthfulness and the ethics of new techniques, just as questions had been asked about Grierson's definition of documentary in the 1930s. And as in the 1930s, it was the raising of questions rather than the often simplistic answers given to them that was productive for the future of documentary form.

The term documentary now covers a great variety of forms, most of them involving a certain amount of 'vérité' and a certain degree of 'creative' treatment of past or present actuality. To cover or even summarize everything that gets included under the heading would be well-nigh impossible, but it is worth singling out two major developments. One is the use of the archive, and the other is the rise of the essay film.

Early documentary, and factual film in general, was of necessity a record of things that had just happened. But as records accumulated, the content locked up in them became more and more a subject of interest to film-makers and historians. Finding, sorting, and editing the requisite materials was at first extremely laborious. It took two years for the Soviet film-maker Esfir Shub to put together her monumental compilation, *The Fall of the Romanov Dynasty*, released in 1927 to celebrate the tenth anniversary of the Bolshevik Revolution. No proper film archives existed and the equipment for cutting, comparing, and keeping to hand the pieces of film was primitive to say the least, with the editor's little cubicle festooned with strips of celluloid hanging up on clothes pegs. It is therefore not surprising if, at first, few film-makers followed in Shub's pioneering footsteps. But as time went on the process became more manageable. The clothes pegs survived for a long time, but sourcing material became easier with the development, from the 1930s onwards, of national film archives and commercial footage libraries. Now, in the digital era, film-makers can call up library footage, store it on a computer, and display it on multiple screens from which to select what they need. The result is that enormous quantities of audiovisual

material from the past hundred years are available for reuse in documentary films and TV programmes.

It is not only material originally shot for the purpose of record that provides the content of the many documentary programmes about the past to be seen on television, and to a lesser extent in the cinema. Clips from fiction films can also be pillaged for the purpose, and whether they show scenes of war-ravaged cities in the 1940s (as in Rossellini's neo-realist classics *Paisà* (1946) and *Germany Year Zero* (1948)) or people dancing in a New York night club in the 1920s, they too provide precious detail about life as it was lived in the 20th century. Jean-Luc Godard's great compilation *Histoire(s) du cinéma* (1988–98) makes wonderfully creative use of material culled from all kinds of sources, making it a history not just of cinema but of the world in which cinema grew up.

Histoire(s) du cinéma is also an example, on a grand scale, of what has come to be called the essay film—as indeed are many of Godard's earlier works. The essay film is an outgrowth of documentary in which, alongside observed facts, the film-maker presents an argument (as a student should in an essay), commenting on them, usually in the first person, and in a questioning mode rather than as a voice of truth. Just as cinéma vérité introduced living testimony into documentary, so the essay film brings in, or brings back, the subjectivity of the film-maker him or herself, reminding the audience that film is not just a passive record of things in the world, but somebody's intervention into how the world can be thought about. And, to the extent that the essay film is reflective and sceptical, it is a very different creature than the propaganda film.

Nowadays relatively few documentaries make it on to the big screen for commercial release, and even the once popular 'rockumentary' featuring a record of a concert performance has faded from sight in the age of music video and the Internet. Such documentaries

as do push themselves forward for public attention tend, perhaps inevitably, to deploy more than the average quantity of rhetoric of one kind or another, as in Michael Moore's *Fahrenheit 9/11* (2004) or *Sicko* (2007). Television, meanwhile, offers up more species of programming in a capacious box bearing the label 'documentary' than one cares to enumerate. On the plus side, no genre has gained more than documentary from the democratic potential of the digital revolution, and in recent years there has been a huge upsurge in semi-professional documentary film-making, not all of which finds an outlet on television or commercially in the cinema.

Cinema and the social imaginary

Although it was the real world in its multifariousness that gave the cinema its choice of what to show, it was how cinema chose to tell stories about what it saw that was decisive for the impact it was to make on the world around it. And it was the real-seemingness of the cinematic image rather than its derivation from real things or its ability to capture the world as such that captured the imagination of audiences. Not only is cinema real-seeming, but it proved to have an unprecedented capacity for connecting with the basic psychic processes of identification and projection. It is through characters that audiences are drawn into the world displayed by the film, and the properties of that world acquire an internal reality for the spectator. Temporarily to be the hero or heroine and to desire or fear what he or she desires or fears, whether another person or a material possession, is fundamental to the experience of fictional forms.

What cinema added was the bodily presence of the objects of fear and desire, and various mechanisms (most obviously the emotive close-up) which brought these objects within reach of the desiring subject. How systematically these mechanisms were brought into play varied considerably. They soon became an integral part of the new narrative syntax that evolved in Hollywood in the late 1910s and early 1920s and eventually spread to the rest of the world,

alongside other features of the classical Hollywood style. But it took time for them to become universal, with Germany and Japan in particular persisting with alternative, less naturalized modes of engaging the audience.

Even in Hollywood itself their deployment was uneven. A Hawks western such as *Rio Bravo* (1959) uses them very little, whereas they are frequent in Hitchcock thrillers such as *Notorious* (1946) or *Psycho* (1960). And when they did spread to cinemas elsewhere, many film-makers actively resisted them, either, as with Robert Bresson in France, in order to establish a sense of distance from the characters or, as with Renoir, to distribute the focus of identification more widely. Then, when they did become more or less universal, countermovements emerged, notably in the 1960s, with film-makers such as Jean-Marie Straub and Danièle Huillet, Jean-Luc Godard, and Nagisa Oshima polemically opposed to any use of devices which associated cinema with the fabrication of illusions and dreams.

Hollywood has often been referred to, usually disparagingly, as a dream factory, and it is certainly the case that for a lot of the time, from the 1920s onwards, it projected to the public an idealized world and an idealized vision of itself as the place from which the vision emanated. So powerful was this projection that Hollywood itself, a small township on the western side of the Los Angeles conurbation, was besieged by hopefuls looking for a job in the movies and possibly stardom—which, of course, few of them achieved.

The main components of the Hollywood dream were sex, money, and adventure. Sex in the movies was highly sublimated, while money and adventure were present in forms way beyond the reach of the average spectator. This did not stop the dream—indeed it intensified it. The appropriateness of the term 'dream' to describe this phenomenon is confirmed by the evidence (mainly anecdotal but nevertheless substantial) that actual dream images were more often experienced in black and white during the middle part of the

20th century and only went into (or back into) colour when that became standard in the cinema and, later, television.

It was not only dreams that entered the public imagination through the cinema. It was also nightmares—of rape, murder, mobsters, monsters, and science-fiction dystopias. The power of nightmares induced by film viewing was recognized quite early on. In 1932, long before it introduced the X certificate to permit adults, but not children, to see moderately sexy films (mainly from continental Europe), the British Board of Film Censors created an 'H' category to prevent children under sixteen from watching horror films (mainly from the USA). But the nightmare universes created in film studios could enter the public imagination in more complex and insidious ways than just by giving a nasty shock to impressionable children.

Looking back over the disasters inflicted on their country in the years from 1933 to 1945, two German Jewish émigré writers, Siegfried Kracauer and Lotte Eisner, came up with different but complementary theses which saw in the irrational currents of the German cinema of the 1920s symptoms of a deep social and cultural malaise whose outcome was to be the rise of Nazism—Kracauer with the provocatively titled *From Caligari to Hitler* in 1947 and Eisner with *L'Écran démoniaque* in 1952. Widely admired at the time they came out, both books have subsequently been much criticized for making extravagant claims on inadequate evidence.

Most of the criticisms, however, miss the point. What Kracauer in particular points to (Eisner rather less so) is the often devious connections that exist, but are not always easy to pin down, between the state of a society and artistic expression. The comparison with Hollywood is illuminating. The world according to Hollywood was on the whole coherent and benign, in line with a society relatively at peace with itself, and its unreality was successfully masked in the form of real-seeming and pleasurable fictions. By contrast, the

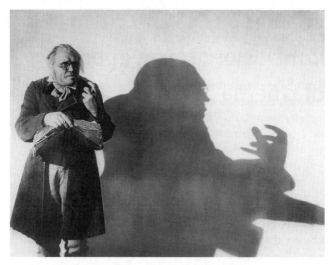

10. Robert Wiene's horror fantasy *The Cabinet of Dr Caligari* (1919).

German cinema had never really embraced the real-seemingness integral to the classical Hollywood style and the consoling sense of naturalness it gave to the mandatory happy ending. Instead, Kracauer suggests, the unresolved irrationality of films like Robert Wiene's *The Cabinet of Dr Caligari* (1919, Figure 10) played, albeit unwittingly, into the generalized climate of anxiety that plagued sections of German society in the Weimar period. Sixty or seventy years on, however, and with irrationality again on the rise in so many parts of the world, Kracauer's thesis in particular is well worth revisiting.

These are deep waters and it is not my intention to venture further into them here. Suffice it to say that, wherever one looks, the more complex and fascinating the connections between inner and outer worlds provoked by cinema prove to be, whether one is dealing with documentary, the supernatural horror film, or the broadly realistic fictions that provide the majority of film viewing across the globe.

Chapter 6
Conclusion: seven epochs of cinema

'The cinematograph', said Auguste Lumière senior, father of the Lumière brothers, 'is an invention without a future.' In the strictest of strict senses he could have been right, because, after a brief flowering, the actual cinematograph as devised by the Lumières faded from sight within a few years of its spectacular inauguration in 1895. But in every other respect he could hardly have been more wrong. For in other hands the cinematograph and similar early inventions went on to become the cinema, and cinema still has a future over a century later.

But in order to get where it is today, cinema did not develop in a straight line, nor did it simply progress to greater and greater achievements or, for that matter, reach a peak from which it subsequently declined in a neat parabolic curve. On the contrary, it developed in different ways in different places at different times, under conflicting pressures and serving changing needs. And in order to develop, it sometimes had to double back on itself, to reject some aspect of what had seemed to be progress and rediscover lost values.

The history of cinema, then, has been a tangled web, which this book has tried to untangle by separating out threads such as technology, industry, artistic forms, and interaction with the

outside world, in different parts of the world at different points in time. By way of conclusion, it is worth weaving these threads together again, but spread out in a chronological line, dividing the history of cinema to date into seven epochs, each of approximately fifteen years' duration.

1900 to 1914: from cinematograph to cinema

The crucial step from the Lumières' cinematograph to what was to become the cinema came around 1900, when it became regular practice to splice different shots together to produce rudimentary narratives or imaginary connections between different elements of a scene. But films remained short, the technology primitive, and the industry ramshackle. Even in 1910, when the technology had been refined, the industry consolidated, and the first feature-length films emerged, it would have been hard to predict the sort of developments that were to be sprung upon the world in just a few years' time.

1915 to 1929: the heyday of the silents

In 1915, with Europe in the throes of World War I, this ramshackle cinema suddenly became the movies—the world's first fully industrialized art form—with its capital in Hollywood, California, but with its organizational systems and storytelling techniques soon spreading throughout the developed world. The movies were the spectacle of modernity, writ large upon the silver screen and in a currency available to all, though the reality of the world they reflected in spectacular form varied according to the distance of the spectator from it—actuality for some, an attainable dream for others, but in parts of the world barely imaginable. Although America led, its model never became quite universal, either in the world it portrayed or in how its stories about it were told, with Germany, Japan, and the Soviet Union all in some way resisting homogenization.

1930 to 1944: the talkies

Fast forward another fifteen years and cinema marched onwards again, as the movies became the talkies. But the introduction of synchronized sound brought contradictory developments and losses as well as gains. National and local cultures gained from the audience's chance to watch films with dialogue in their own language. But the exigencies of sound recording drove film-making into the studio and promoted forms of storytelling which were naturalistic, even if the settings were no longer natural. Montage was sidelined as an alternative form of creating meaning. Spectacle was diminished, except in the musical. The oscillation between the values of spectacle and impulses pushing in the direction of realism was later to become an even more prominent feature of the cinema.

1945 to 1959: after World War II

For the first half century or so of its existence the cinema had developed smoothly, and in largely self-determining ways. Technology continued to be refined, industry consolidated, and a straightforward storytelling language had come into being with which audiences across the world could engage. There was interaction with the outside world, but never of a kind to cast doubt on the mainly progressive narrative according to which cinema was to be imagined.

World War II and its aftermath cast this narrative into doubt. Hollywood acted swiftly to regain lost markets in Western Europe, but its eastward march was halted by the Cold War. Independence in 1947 gave a new stimulus to Indian cinema. Realism returned to vogue, most notably in Italy, where the neo-realists took film-making back out into the streets, partly for a lack of functioning studio facilities but mainly out of a desire to document the world

as it was in the contested political climate. Realism of a more conventional kind became the orthodoxy throughout the Soviet bloc.

Hollywood vacillated, finally coming down on the side of spectacle with the generalization of Technicolor and the arrival of widescreen, inspired by the need to compete with the emerging medium of television. Artistically the 1950s was a decade of stabilization. There was continuity as well as change. When the young critics on *Cahiers du cinéma* formulated their list of the four greatest living film-makers in the early 1950s, only one—Rossellini—was a newcomer; the other three—Renoir, Hitchcock, and Hawks—had all been active since the silent period.

1960 to 1974: the new waves

While the effect on cinema of the aftermath of war might have been predicted, what happened next was not. Around 1960 a small revolution took place in world cinema. Under the influence of neo-realism, new small-scale cinemas sprang up across the globe, starting with the French New Wave and spreading rapidly to Eastern Europe, Japan, Cuba, Brazil, and other countries. New lightweight technology made possible a completely new style of documentary, known variously as direct cinema and cinéma vérité. Art cinema throve. The artistic avant-gardes revived, especially in the USA.

Criticism in the English-speaking world belatedly woke up to the artistic merits of the Hollywood movie, but meanwhile Hollywood itself entered into a period of crisis, artistically stale and unable to adapt to the loss of its increasingly fragmented audience to television and (to a lesser extent) competition from low-budget exploitation films and foreign imports. Relaxation of censorship in 1966 brought some relief, but by 1970 the much-vaunted Hollywood system found itself on the verge of collapse.

1975 to 1989: the empire strikes back

By 1975 the new cinemas had more or less played themselves out. Some (Czechoslovakia, Brazil) had already fallen victim to political repression, the others simply lost their novelty and power to attract. Hollywood, by contrast, staged a strong recovery. Industrially less rigid and less heavily self-censoring, the new Hollywood found ways to appeal to the different demographics composing the audience in a period of social and cultural change.

Dolby stereo and body-miking re-established Hollywood's lead in sound technology, both for studio and location effects. At the other end of the technology spectrum, video recording created new opportunities for small-scale film-making and opened up a new market for the non-theatrical viewing of mainstream films, which the studios, now reorganized as multimedia conglomerates, soon learnt to exploit.

1990 to the present

The fall of Communism and widespread trade liberalization from 1990 onwards opened up the global film market—mainly to the advantage of Hollywood but with broader effects, particularly in Asia. Only Indian cinema remained to some extent outside the loop, importing little and making distinctive films to serve not just a huge home market but an extensive diaspora and audiences in the Muslim world as well.

The new pattern of trade and culture flows made the cinema increasingly transnational and has been greatly aided by the arrival of digital platforms for the circulation of films of all types, from the latest blockbusters (often pirated) to rarities from the archive now available on DVD or as downloads. Digital has also affected production, with CGI replacing the cumbersome special effects of yesteryear. It has also facilitated low-end production

and enabled the cinema, or at least a small part of it, to recover its alternative destiny not as a manipulator of imaginary times and spaces but as a record of things happening in natural space and time. Dispersed across a variety of platforms, and not always immediately visible to the casual spectator simply seeking a traditional good night out at the movies, cinema is now more varied than ever. The end of celluloid may be approaching but not necessarily the end of cinema.

As this brief summary shows, the history of cinema over the past hundred and more years has been one of constant readjustment—upwards, downwards, or sideways—to new challenges and opportunities. Throughout this period, cinema has been many things, but its core identity, based on the one hand on the underlying realism of the photographic image and on the other hand on cinema's ability to draw audiences together to watch real-seeming events unfolding on a big screen, has remained the same. This core identity has, however, been progressively eroded on all sides. The process of erosion has been going on for at least thirty years, but its effects are only now making themselves felt to the point of threatening cinema's specialness in the new multimedia, multiplatform universe.

Cinema still celebrates itself as something special, most flamboyantly at the annual Academy Award 'Oscars' jamboree in Los Angeles, but also at film festivals around the world showcasing a wider range of films than fall within the Academy's blinkered purview. But the multiplication of viewing platforms for moving images of all sorts has created a confusing and at times paradoxical situation in which cinema as traditionally understood is rapidly losing its specialness and even its identity. On the one side, digital images of quasi-cinematic quality can be made to be viewed on a large screen as part of an art installation, while on the other side, actual cinema films can be downloaded for viewing, sorely diminished, on the tiny screen of a mobile phone. The viewing experience can be immersive, as cinema viewing has mostly aspired to be, and

is replicated in visual reality displays; or it can be contemplative, critical, or even distracted.

The cinema has reacted in various ways to this confused situation. Realizing that small-screen formats cannot produce the grand spectacle for which cinema is famous, exploitation-oriented producers have increased the dosage of moments of sensation to jolt distracted spectators out of their apathy, while at the other end of the spectrum 'slow cinema' relies on being able to create forms of attentiveness different from those customary either in cinema or on TV.

This is not the apocalypse. Cinema will continue to do the things it is best at, whether realistic or fantastical, and find audiences for what it alone has to offer. As the various things that today go under the name cinema either disperse or merge into other forms of media, they may well have to find themselves a new name or set of names. But whatever name they continue under in the future, under the name cinema these things will have had a history, and that cannot be taken away.

Notes and further reading

Throughout this book I have drawn heavily on my edited volume, *The Oxford History of World Cinema* (Oxford University Press, 1996), to whose many contributors, not all acknowledged in these pages, I here express my gratitude.

Especially for the more recent period I have also drawn on Kristin Thompson and David Bordwell's *Film History: An Introduction*, 3rd edition (McGraw Hill, 2010), which in spite of its modest title is a massive scholarly compendium covering all aspects of cinema and its history.

Among other works dealing with film historiography and the history of cinema in general, some worth noting are: Robert C. Allen and Douglas Gomery (eds), *Film History: Theory and Practice* (Knopf, 1985), and William Guynn (ed.), *The Routledge Companion to Film History* (Routledge, 2011). For the cinema that has dominated the world since the end of World War I, Richard Maltby's *The Hollywood Cinema*, 2nd edition (Wiley-Blackwell, 2003) is invaluable.

Throughout this book films are mostly referred to under their generally accepted English title, where they have one, and referenced to the name of their director. But a few French or Italian films are referred to under their original titles, either because they never got an English title (e.g. Mario Camerini's 1937 comedy *Il signor Max*); or because they were released under their original title, which has then stuck (e.g. Michelangelo Antonioni's *L'avventura* from 1960); or because they had a translated or quasi-translated title only on one side

of the Atlantic (e.g. Roberto Rossellini's 1946 *Paisà*, known in the USA as *Paisan*); or because the English title is in some way aberrant, as with the literal but meaningless translation of François Truffaut's 1959 debut feature *Les Quatre Cents Coups* as *The Four Hundred Blows*.

It is also the case that the director is not always the most important person (or the single most important person) involved in the production of a film, or the person most relevant to the aspect of a film under discussion. (This was particularly the case in the American cinema of the 'classical' period, up to 1960 or thereabouts.) So although I have mostly followed the convention of giving the name of the director (and date of release) when a film is first referred to, I have not made a fetish of it, and for a handful of films I have included the name of the principal scriptwriter (e.g. Jacques Prévert alongside Marcel Carné for the 1939 film noir *Le Jour se lève*), while for *Gone with the Wind* (also 1939) I have referenced only the producer, David O. Selznick, rather than Victor Fleming who directed most (though not all) of it under Selznick's supervision.

Chapter 1: Introduction

The seminal notion of cinema as 'the completion [*achèvement*] in time of the objectivity of the photograph' comes from an essay by the French critic André Bazin (1918–58) first published in 1945. For more on Bazin and his influential writings collected under the title *What Is Cinema?*, see Chapter 4, pp. 63–4 and 108.

For the parallel notion of what history is, E. H. Carr's *What Is History?*, first published in 1961 by Cambridge University Press and reprinted many times in paperbacks on both sides of the Atlantic, remains unsurpassed as a lucid guide to the problems of historiography fifty years on.

The menarche/monarchy slogan, which dates from the mid-1970s, is a kind of *reductio ad absurdum* of the contrast elaborated by French historians of the 'Annales' school thirty years earlier between traditional 'event history' (*histoire événementielle*) and what they called 'structural history' (*histoire structurale*). By the time the new structural history had reached the English-speaking world, event history had staged a comeback (what could be more *événementiel* than the 'events' in Paris in May 1968?). The slogan was immediately

derided by conservative historians and further criticized, this time
from the left, in an essay by the late Tony Judt, 'A Clown in Regal
Purple', *History Workshop Journal*, 7, Spring 1979, pp. 66–94.

For the 'new' film history as it developed in the 1980s, see Allen and
Gomery, *Film History* (Knopf, 1985).

Chapter 2: Technology

For early film technology, see Paolo Cherchi Usai, 'Origins and Survival',
in *The Oxford History of World Cinema*, pp. 6–13.

For the coming of sound, a good summary is in Karel Dibbets, 'The
Introduction of Sound', in *The Oxford History of World Cinema*,
pp. 211–19; while for sound cinema more widely, two useful guides are
Elisabeth Weis and John Belton (eds), *Film Sound: Theory and
Practice* (Columbia University Press, 1985) and Michel Chion,
Audio-Vision: Sound on Screen (Columbia University Press, 1994).

For widescreen cinema, and for the relationship of technology to wider
developments in cinema, see John Belton, *Widescreen Cinema*
(Harvard University Press, 1992).

Chapter 3: Industry

Malraux's throwaway remark comes at the very end of his *Esquisse
d'une psychologie du cinéma*, first published by Gallimard in 1944.

The early history of the film trade is explored in Kristin Thompson,
Exporting Entertainment (British Film Institute, 1985). For the
Hollywood cinema from the 1910s onwards, key sources are Maltby,
The Hollywood Cinema (2003), and David Bordwell, Janet Staiger,
and Kristin Thompson's pioneering work, *The Classical Hollywood
Cinema* (Routledge and Kegan Paul, 1985). For cinemas other than
the American, and for a world perspective up to 1995, see the relevant
chapters in *The Oxford History of World Cinema*.

Chapter 4: Cinema as art form

Canudo's and Epstein's essays can be found in Richard Abel,
French Film Theory and Criticism: A History/Anthology, Vol. I

1907–1929 (Princeton University Press, 1988) on pp. 58–65 and 314–16 respectively.

No actual footage of Kuleshov's experiment has survived, leading some scholars to doubt if it ever took place, although it almost certainly did. The account here is as given by Natalia Nussinova in *The Oxford History of World Cinema*, p. 167.

Eisenstein's essay 'Laocoön' is in S. M. Eisenstein, *Selected Works, Vol II, Towards a Theory of Montage*, translated by Michael Glenny (British Film Institute, 1991), pp. 109–202.

For the idea of early cinema as a cinema of attraction, see Tom Gunning, 'The Cinema of Attraction: Early Film, Its Spectator and the Avant-Garde', *Wide Angle*, 8(3/4), Fall 1986. For the development of the 'classical' style of film editing, see Bordwell, Staiger, and Thompson, *The Classical Hollywood Cinema* (1985), pp. 3–84.

Steiner's score for *Casablanca* is analysed in Martin Marks, 'The Sound of Music', in *The Oxford History of World Cinema*, pp. 253–5. For film music more generally, Kathryn Kalinak's *Film Music* (Oxford University Press, 2010) is an ideal short introduction. Also highly recommended are Claudia Gorbman, *Unheard Melodies: Narrative Film Music* (Indiana University Press/British Film Institute, 1987) and Michel Chion, *La Musique au cinéma* (Fayard, 1995).

The term 'biopic' (Hollywoodese for biographical motion picture and best pronounced BUY-opic) could also be applied to Straub and Huillet's *Chronicle of Anna Magdalena Bach*, though almost certainly against the wishes of the film's authors.

Zavattini's phrase 'hunger for reality' comes from his essay 'Alcune idee sul cinema', first published in 1952 and reprinted in Cesare Zavattini, *Neorealismo ecc* (Bompiani, 1979), pp. 95ff. A partial English translation can be found in David Overby (ed.), *Springtime in Italy: A Reader on Neo-Realism* (Talisman Books, 1978).

Bazin's writings from the 1940s and 1950s were brought together in four slim volumes under the title *Qu'est-ce que le cinéma?* (Éditions du Cerf, 1958–62). Selected English translations were published by University of California Press in two volumes under the title

What Is Cinema? (1967 and 1971), translated by Hugh Gray, and more recently by Caboose (Montreal) under the same title, edited and translated by Timothy Barnard (2009). The Barnard version is far superior but, for copyright reasons, not easily available in Britain or the USA. The notion of cinema as 'the completion [*achèvement*] in time of the objectivity of the photograph' first appears in his essay 'Ontology of the Photographic Image' in volume one of *Qu'est-ce que le cinéma*, *Ontologie et langage*, p. 16 (in English in Gray, p. 14 and Barnard, p. 8).

Selected texts from *Cahiers* are in English in Jim Hillier (ed.), *Cahiers du Cinéma: The 1950s* and *Cahiers du Cinéma: The 1960s* (Routledge, 1985, and Harvard University Press, 1986).

For the belated effect of modernism on cinema, see Sam Rohdie, *Film: Modernism* (Manchester University Press, 2015).

For film noir, see James Naremore, *More than Night: Film Noir in its Contexts*, revised edition (California University Press, 2008).

Chapter 5: Cinema and the outer world

Lenin's remark (later echoed by Mussolini as 'the cinema is the state's most important weapon') was made in a conversation with Anatoly Lunacharsky, first published in 1925 and reprinted in English translation in Richard Taylor and Ian Christie (eds), *The Film Factory: Russian and Soviet Cinema in Documents, 1896–1939* (Harvard University Press, 1988), pp. 56–7.

For censorship, see Linda Williams, 'Sex and Sensation', *The Oxford History of World Cinema*, p. 490, and Richard Maltby, 'Censorship and Self-Regulation', *The Oxford History of World Cinema*, p. 235. The text of the Production (or 'Hays') Code as originally formulated in 1930 is in Maltby, *The Hollywood Cinema*, pp. 598–600.

Peter Kenez's acerbic summing up of the paradoxes of Socialist Realism comes from his chapter, 'Soviet Film Under Stalin', in *The Oxford History of World Cinema*, p. 389. For Socialist Realism, see also Taylor and Christie, *The Film Factory*, pp. 331–97.

For Grierson's philosophical background and ideas, see Ian Aitken, *John Grierson and the Documentary Film Movement* (Routledge,

1990), while the truth claims of both Griersonian documentary and cinéma vérité are subject to scathing criticism in Brian Winston, *Claiming the Real: The Documentary Film Revisited* (British Film Institute, 1995). The quotation from Michael Renov come from his essay 'Towards a Poetics of Documentary', in Michael Renov (ed.), *Theorizing Documentary* (Routledge, 1993), p. 21.

The phenomenon of dreaming in black and white, now thought to be confined to the generation which grew up in the heyday of black-and-white movies and television, has recently attracted the belated attention of psychologists and scientists. See <http://www.nytimes.com/2008/12/02/health/02real.html>.

Siegfried Kracauer, *From Caligari to Hitler* (Princeton University Press, 1947). Lotte Eisner, *L'Écran démoniaque* (André Bonne, 1952); in English as *The Haunted Screen* (Thames & Hudson, 1969). Kracauer's thesis (far more sophisticated than his Anglo-Saxon detractors have claimed) is lucidly summarized in Thomas Elsaesser, *Weimar Cinema and After: Germany's Historical Imaginary* (Routledge, 2000), pp. 28–37.

General index

General index

Index of film titles

SOCIAL MEDIA
Very Short Introduction

Join our community

www.oup.com/vsi

- Join us online at the official Very Short Introductions
 Facebook page.
- Access the thoughts and musings of our authors with our
 online **blog**.
- Sign up for our monthly **e-newsletter** to receive information
 on all new titles publishing that month.
- Browse the full range of Very Short Introductions online.
- Read **extracts** from the Introductions for free.
- If you are a teacher or lecturer you can order inspection
 copies quickly and simply via our website.

FILM
A Very Short Introduction
Michael Wood

Film is considered by some to be the most dominant art form of the twentieth century. It is many things, but it has become above all a means of telling stories through images and sounds. The stories are often offered to us as quite false, frankly and beautifully fantastic, and they are sometimes insistently said to be true. But they are stories in both cases, and there are very few films, even in avant-garde art, that don't imply or quietly slip into narrative. This story element is important, and is closely connected with the simplest fact about moving pictures: they do move. In this *Very Short Introduction* Michael Wood provides a brief history and examination of the nature of the medium of film, considering its role and impact on society as well as its future in the digital age.

DOCUMENTARY FILM
A Very Short Introduction
Patricia Aufderheide

Beginning with an overview of the central issues of
documentary filmmaking--its definitions and purposes, its
forms and founders--Aufderheide focuses on several of its key
subgenres, including public affairs films, government
propaganda (particularly the works produced during World
War II), historical documentaries, and nature films. Her
thematic approach allows readers to enter the subject matter
through the kinds of films that first attracted them to
documentaries, and it permits her to make connections
between eras, as well as revealing the ongoing nature of
documentary's core controversies involving objectivity,
advocacy, and bias.

> Always clear and concise . . . a welcome addition to the *Very Short
> Introductions* series.

> **The Observer**

FILM MUSIC
A Very Short Introduction
Kathryn Kalinak

This *Very Short Introduction* provides a lucid, accessible, and engaging overview of the subject of film music. Beginning with an analysis of the music from a well-known sequence in the film Reservoir Dogs, the book focuses on the most central issues in the practice of film music. Expert author Kay Kalinak takes readers behind the scenes to understand both the practical aspects of film music - what it is and how it is composed - and also the theories that have been developed to explain why film musicworks. This compact book not entertains with the fascinating stories of the composers and performers who have shaped film music across the globe but also gives readers a broad sense for the key questions in film music studies today.

'Kathryn Kalinak has emerged as one of the freshest and most authoritative commentatory on film music of her generation.'

Michael Quinn, Classical Music

www.oup.com/vsi

ADVERTISING
A Very Short Introduction
Winston Fletcher

The book contains a short history of advertising and an explanation of how the industry works, and how each of the parties (the advertisers , the media and the agencies) are involved. It considers the extensive spectrum of advertisers and their individual needs. It also looks at the financial side of advertising and asks how advertisers know if they have been successful, or whether the money they have spent has in fact been wasted. Fletcher concludes with a discussion about the controversial and unacceptable areas of advertising such as advertising products to children and advertising products such as cigarettes and alcohol. He also discusses the benefits of advertising and what the future may hold for the industry.

www.oup.com/vsi

GLOBALIZATION
A Very Short Introduction
Manfred Steger

'Globalization' has become one of the defining buzzwords of our time - a term that describes a variety of accelerating economic, political, cultural, ideological, and environmental processes that are rapidly altering our experience of the world. It is by its nature a dynamic topic - and this *Very Short Introduction* has been fully updated for 2009, to include developments in global politics, the impact of terrorism, and environmental issues. Presenting globalization in accessible language as a multifaceted process encompassing global, regional, and local aspects of social life, Manfred B. Steger looks at its causes and effects, examines whether it is a new phenomenon, and explores the question of whether, ultimately, globalization is a good or a bad thing.

www.oup.com/vsi

THE MEANING OF LIFE
A Very Short Introduction
Terry Eagleton

'Philosophers have an infuriating habit of analysing questions rather than answering them', writes Terry Eagleton, who, in these pages, asks the most important question any of us ever ask, and attempts to answer it. So what is the meaning of life? In this witty, spirited, and stimulating inquiry, Eagleton shows how centuries of thinkers - from Shakespeare and Schopenhauer to Marx, Sartre and Beckett - have tackled the question. Refusing to settle for the bland and boring, Eagleton reveals with a mixture of humour and intellectual rigour how the question has become particularly problematic in modern times. Instead of addressing it head-on, we take refuge from the feelings of 'meaninglessness' in our lives by filling them with a multitude of different things: from football and sex, to New Age religions and fundamentalism.

'Light hearted but never flippant.'

The Guardian.

www.oup.com/vsi